figure

HOW TO DRAW &
PAINT THE FIGURE
WITH **IMPACT**

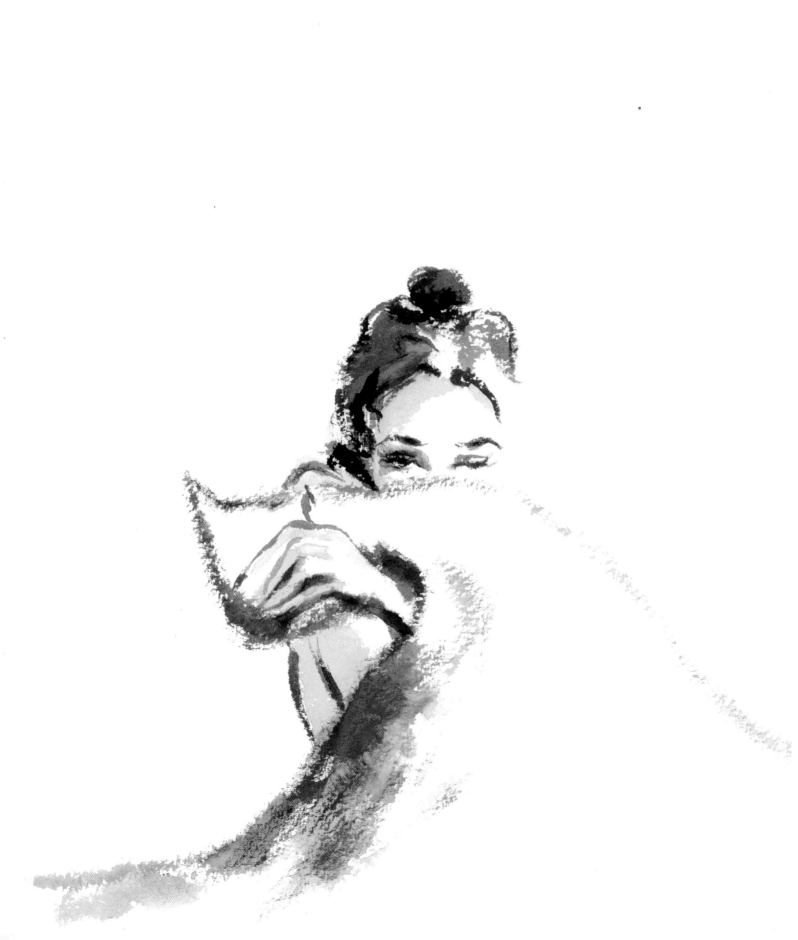

figure

HOW TO DRAW & PAINT THE FIGURE WITH **IMPACT**

SHARON PINSKER

D&C
David and Charles

To my mother and father,
Ana and Harry Pinsker

A DAVID & CHARLES BOOK
Copyright © David & Charles Limited 2008

David & Charles is an F+W Publications Inc. company
4700 East Galbraith Road, Cincinnati, OH 45236

First published in the UK in 2008
Reprinted 2008

Text and illustrations copyright © Sharon Pinsker 2008

A catalogue record for this book is available from the British Library.

ISBN-13: 978-0-7153-2601-5 hardback
ISBN-10: 0-7153-2601-5

ISBN-13: 978-0-7153-2597-1 paperback
ISBN-10: 0-7153-2597-3

Printed in the USA by CJ Krebiel
for David & Charles
Brunel House Newton Abbot Devon

AUTHOR DISCLAIMER
All reasonable efforts and endeavours have been made to contact
all individuals depicted in these illustrations and reproduced in this
publication. Apologies should there be any errors or omissions
made to trace and acknowledge copyright of illustrations shown.

Senior Commissioning Editor Freya Dangerfield
Senior Editor Jennifer Fox-Proverbs
Art Editor Sarah Underhill
Designer Alistair Barnes
Production Controller Kelly Smith

Visit our website at www.davidandcharles.co.uk

David & Charles books are available from all good bookshops;
alternatively you can contact our Orderline on 0870 9908222 or
write to us at FREEPOST EX2 110, D&C Direct, Newton Abbot, TQ12
4ZZ (no stamp required UK only); US customers call 800-289-0963
and Canadian customers call 800-840-5220.

contents

INTRODUCTION

Painting and drawing people has been the motivation behind my work for as long as I can remember. I have never yet found anything more addictive and challenging than trying to capture the complex beauty and mystery of the human figure.

I was very fortunate to have been taught figure drawing by inspirational artists like David Carr and Sargy Mann. In retrospect I think It was also lucky that when it came to applying for a degree course at the London based Central Saint Martins College of Art and Design, I opted to study what was the less obvious choice for someone obsessed with life drawing and painting people – fashion design.

I only did that because I couldn't imagine fitting into the Fine Art department. In the late 1970s my interest in academic figure drawing was considered conservative and surplus to requirement in the days when, 20 years before Brit art, 'found sculpture' from the contents of rubbish skips and putting rotting fish in perspex box frames was all the rage. So I opted for the Fashion department because here understanding the human form and how it moved was essential to being able to design clothes for it. This provided the means with which I could pursue my real passion.

Having long been inspired by painters like Gustav Klimt, Egon Schiele and Henri Matisse, now I was introduced to the work of fashion artists like Rene Gruau and Rene Bouche. It was never a secret that I was more interested in drawing the models in the clothes than the clothes themselves. Again I was lucky to win a place at Parsons School of Design in New York for a postgraduate degree, where they had a separate fashion illustration course.

Striving to capture the essence and personality of a model, maintaining spontaneity with expressive gestural marks; of silhouettes; of details; the

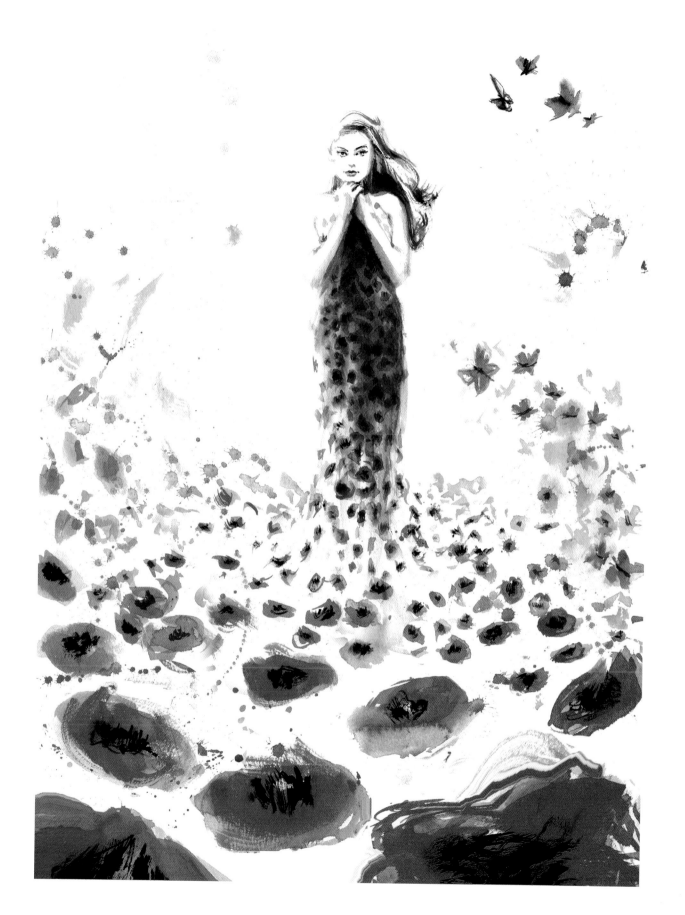

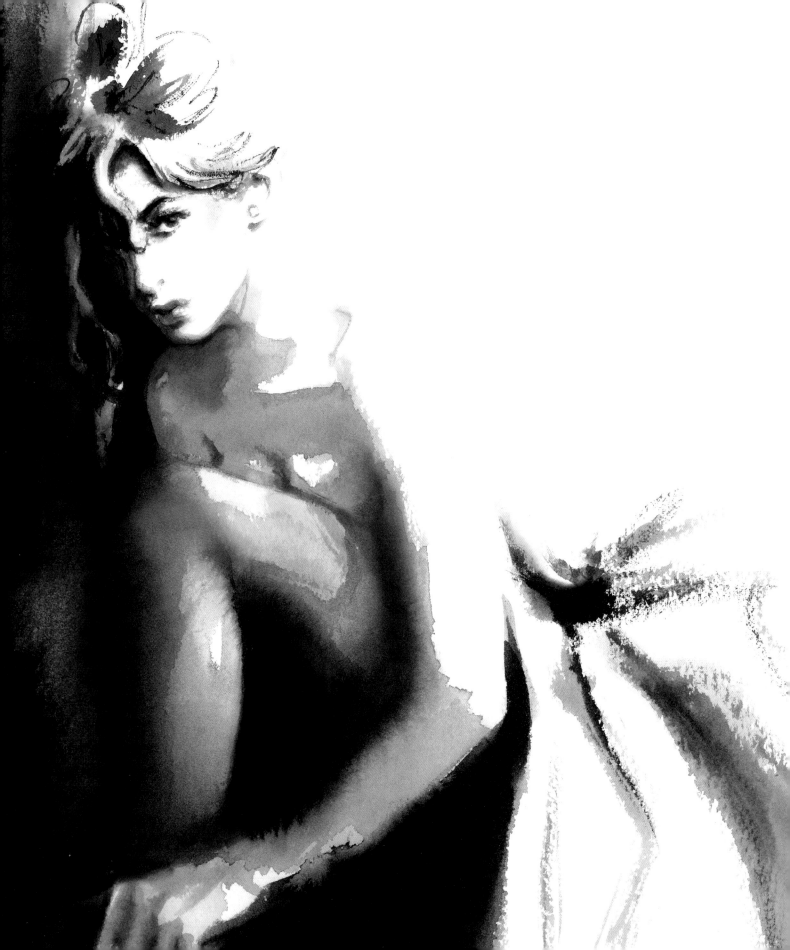

figure in motion, its beauty and elegance; learning to design the figure on the page; the importance of white space – these things all led from figure drawing to fashion, portrait painting and into film storyboard, commercials animation design and art direction. It seemed like a natural progression of events. Thinking about the requirements for drawing the figure in one situation gradually led to the next but it was always completely accidental and unplanned.

The vast majority of the work I have done is rolled up in tubes or in big black portfolios gathering dust in a cupboard under my stairs. If a few images manage to end up on a book cover or displayed on the sides of buses or on hoardings over a motorway, or occasionally make an appearance on TV in the form of an animated commercial or music promo; then again this has been largely due to luck rather than judgement! One thing is certain though – almost every image I can remember being employed to do has required me, in one way or another, to draw on the thought processes and exercises I have laid out here in this book. Things that have occurred to me over the years that are useful cross references between the different experiences I have had working in these particular fields.

The book is divided into three main sections, each broken down into subject areas that deal with the challenges of drawing and painting the figure with impact. I have included thought processes and ideas, exercises and incidental experiences that have proven helpful to me; accompanying these are examples of my work to illustrate the hows and whys. No matter who you are, whether you have some experience of figure drawing and are thinking about taking it further or in another direction, or even if you are just curious about approaching the same problems associated with painting and drawing the figure from another perspective, then I hope this book will prove useful to you.

LULU AND LYDIA
Lulu opposite and Lydia on the previous page are examples of images combining the abstract with the literal in order to illustrate a fictional character.

Rather than being a list of technical hints and formulae, this book is intended to be, I hope, like having a discussion about your work with someone who shares a fascination with the endless challenge in drawing and painting the figure; the attempt to continuously study something and yet to always try to see it as if for the very first time . . .

THE BODY

It would be impossible to describe a figure in words — how it works, its complex components and the way they work together — without first truly understanding it. In the same way, it would be futile to attempt to create a convincing image of a figure without having a good understanding of it. Modigliani and Matisse, for instance, knew the body so well they could draw it with only a few perfectly shaped and placed marks.

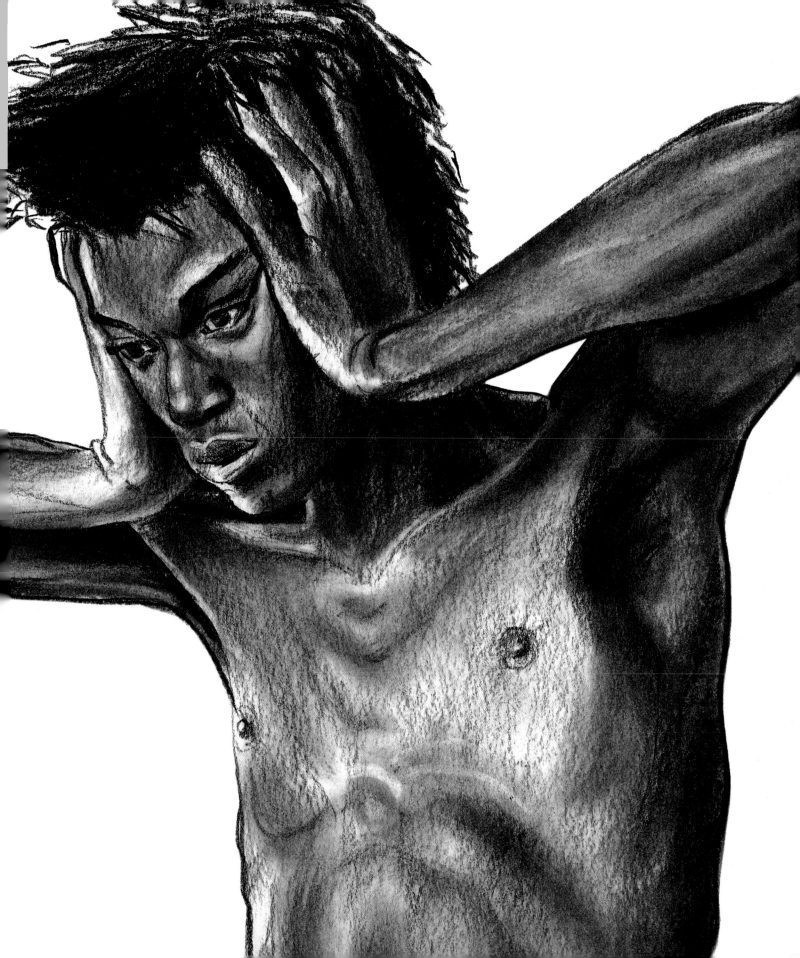

core

Study the skeleton and muscle formation and how the balance and weight of bones, joints and muscles work when the figure is static and in motion — a good aid to this is looking at a skeleton — but remember when you approach a drawing that the model is made of living flesh and blood, or 'meat and electricity' as Sigmund Freud put it. It is not an anatomical or technical drawing you are creating.

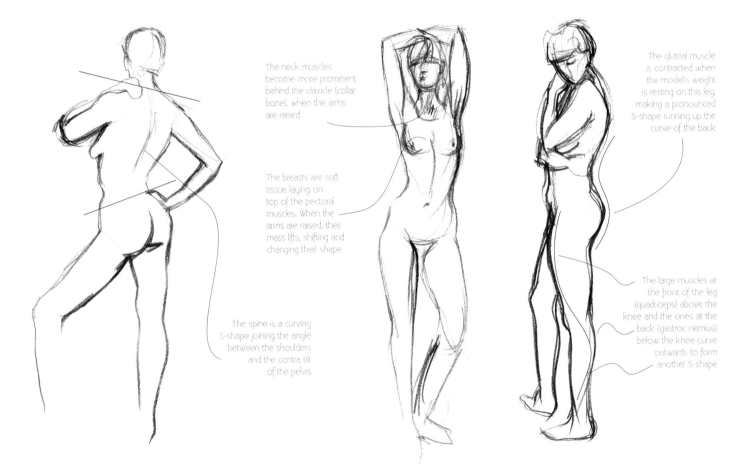

The neck muscles become more prominent behind the clavicle (collar bone), when the arms are raised

The breasts are soft tissue laying on top of the pectoral muscles. When the arms are raised, their mass lifts, shifting and changing their shape

The spine is a curving S-shape joining the angle between the shoulders and the contra tilt of the pelvis

The gluteal muscle is contracted when the model's weight is resting on this leg, making a pronounced S-shape running up the curve of the back

The large muscles at the front of the leg (quadriceps) above the knee and the ones at the back (gastroc nemius) below the knee curve outwards to form another S-shape

Finding the centre of balance in a pose and where the tension is held will help you create movement in what may be a physically static pose. Life drawing will help you to practice observational skills and to understand the basic structure and mechanical workings of the human body, and how it moves. My sister, who is an osteopath, has a skeleton in her surgery, and studying it, as well as some of her anatomy books, has been a great way for me to learn about the mechanics of the figure.

SHAPES FROM MUSCLES
Look for shapes and curves made by contracted and relaxed muscles as these help to give the figure rhythm and movement as well as defining its form.

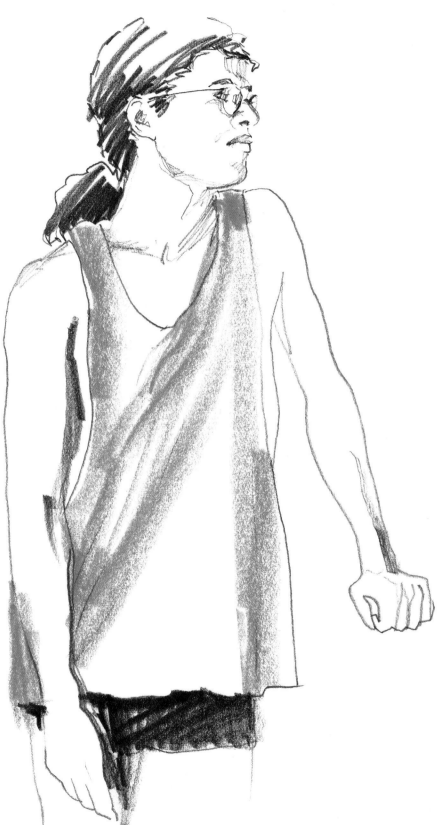

TENSION
There is a tension in the arm here as the model leans on the back of a chair. Even though the chair is not shown in the drawing, the contrast between the relaxed arm and the one bearing weight is clearly visible.

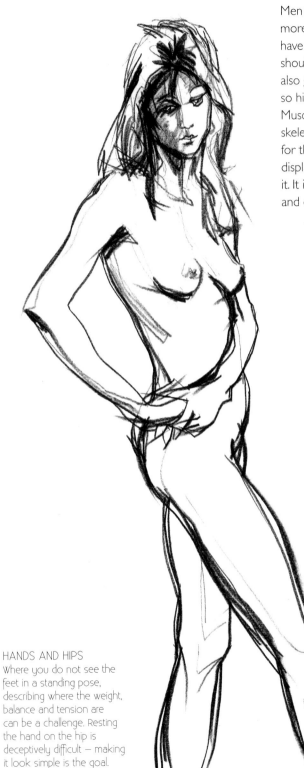

MUSCLES AND TENSION

Men tend to have proportionately less body fat and more muscle than women. Even a slim woman may have more fat resting on her hips than a man. His shoulders and neck are generally broader, which also gives his hips the appearance of being narrower, so his waist will not appear to be so pronounced. Muscles will tense and contract while working on the skeleton in order to move or hold a position. Look for this tension and relaxation in the muscles and the displacement of the flesh and fat that results from it. It is these shapes that will help you to understand and draw the undulating contours of the figure.

FINDING A THEME
Before starting a drawing, decide what you want to say in it. What was striking about this pose was the similarity between the shape and contours of the model's plaited hair and the vertibrae and bones visible in her back.

HANDS AND HIPS
Where you do not see the feet in a standing pose, describing where the weight, balance and tension are can be a challenge. Resting the hand on the hip is deceptively difficult — making it look simple is the goal.

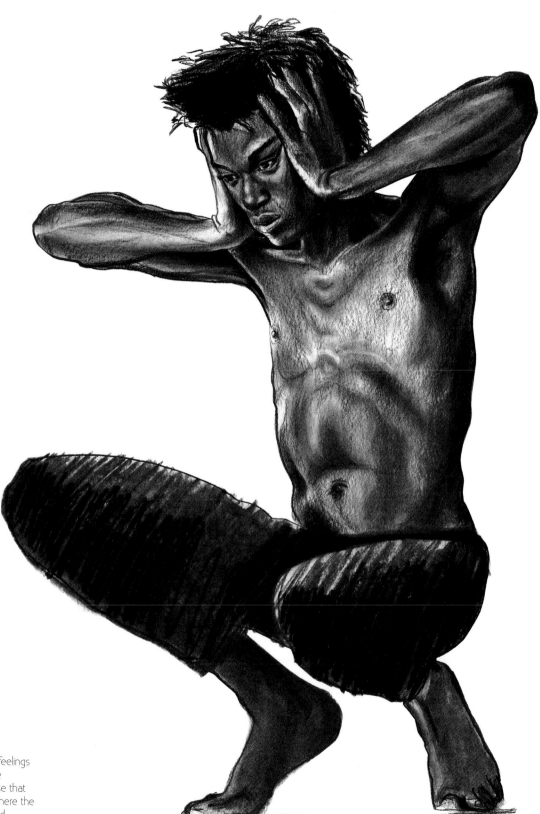

TRY THE POSE
Just as an actor playing a role explores the feelings of his character, so it is useful to get into the position of the model, especially if it is a pose that is difficult to hold. In this way you can feel where the strength, stretch, tension and balance are held.

figures

There are, of course, anatomical differences between men and women in terms of shape and proportions, but it is important to approach each drawing with fresh eyes and without preconceived ideas. Study your sitter closely and look out for what makes them unique rather than working through a tick-list of masculine or feminine characteristics.

LOOK FOR THE UNUSUAL
This crayon drawing in a small sketchbook has few lines, apart from along her back, that may be typically regarded as feminine. Although the duvet hides part of the model's body, it helps define the most difficult and unusual part of the pose, which is the arm she is leaning on.

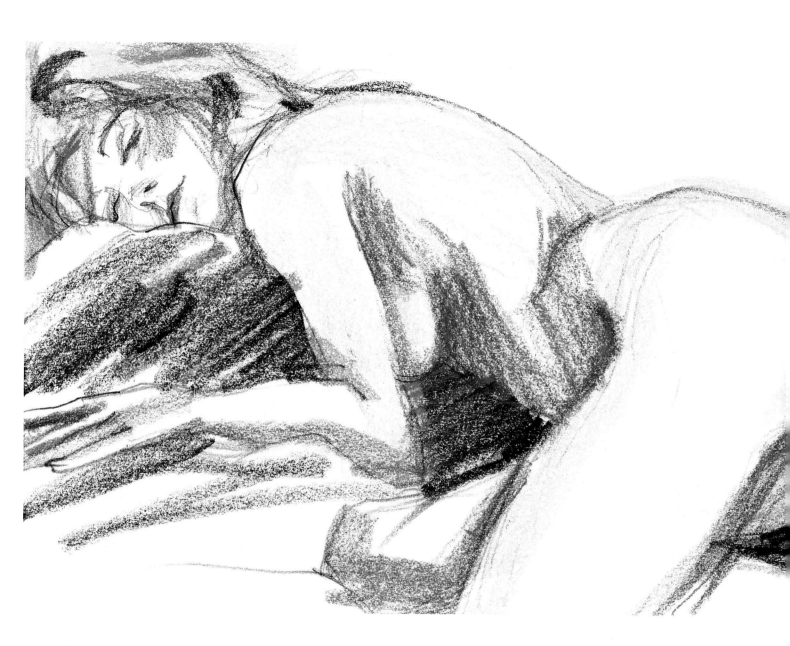

Body shapes

It can be difficult to categorize models as either masculine or feminine; there are feminine men and masculine women. There are, however, ways of working towards capturing a faithful and successful representation of a subject. By examining closely where the figure's centre of balance is, how his or her features work in relationship to each other, and by communicating what the sitter is feeling you will find that their masculinity or femininity will come across naturally.

Proportions

Look for something unusual in the pose of the model each time you draw. It may be the way light falls across the model's body, a specific stance, or a twisted position that becomes a central element of the drawing and so creates a unique tension. This is as true for static poses as for those of figures in motion. It is important to remember that you are drawing a living, breathing person and not creating an architectural plan, so tape measures and plumb lines aren't necessary. You can capture the sitter's essence without being obsessive about proportions.

ENERGETIC MARKS

Direct and expressive marks are ideal for explorative sketchbook drawings, even one such as this relaxed pose. My approach and the marks used are the same whether drawing a man or a woman. By looking closely and continually repeating the exercise, drawings become truer to what is seen and what needs to be said.

Motion

The best way to draw figures in motion is to simultaneously watch and draw them quickly. By this I mean try to draw the figures while looking at them rather than looking at the drawing. You will, of course, have to look at the drawing from time to time, but try to keep it to a minimum. If you can film the moving figure that can be a great help because you can rewind and rewatch the action. In this way if you can draw with speed you will capture the impression of the whole movement. Taking a still photograph of someone in motion is deceptively useless; it will show only the frozen action, giving the anatomy of the pose, but it will appear static. The flow and rhythm of the action, the thrust of movement and the tension of the muscles all need to be evident to make the drawing believable.

DIRECTIONAL LINES
By tracing the action from where it came from to where it is going and using directional lines to describe its energy, you will be able to describe the movement.

TENSION AND ENERGY
Quick sketches made by putting down the shape of the movement and then drawing into it will give you the tension and energy of the action. Elegant C-shapes formed by arched torsos are exaggerated by the outstretched arms and legs.

FIGURES IN MOTION
These drawings are preliminary character sketches for the Cirque du Soleil. I was given still images as reference, which showed how the performer held a pose but the movement had to be created in the drawing. Apparent movement was achieved through the flowing hair, the varied thick and thin directional lines and the vitality of the marks.

CLOTHED AND NUDE

You can't make a drawing of a clothed figure convincing unless you have a good understanding of what that figure looks like without clothes on. Try drawing a model who is at first nude, and then in the same position, but clothed.

Think about anatomical forms such as shoulder blades and suggest their position beneath the clothing. This will help the fabric to shape around the figure and not appear flat or cut out

The direction of lines where the arm meets the torso will also show you the change in direction of the fabric and where it creases

If you follow the contour lines, tracing along them with a pencil as if it was touching the body, you will feel the change in direction as it goes into the valley at the back of the knee, and automatically change the stroke of the pencil to make this dip

Remembering how the pencil stroke changed to trace into the back of the knee, apply the same action to draw the fabric over the clothed leg

faces

Because human beings usually engage with each other by looking into their eyes, the face is the area of the body in which we naturally place most importance and attention. But when making a study of the face in a drawing, try to approach it in the same way as you would in any other subject of complex facets, planes and textures.

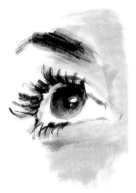

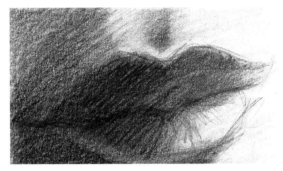

LIP SHAPES
Women tend to have a more prominent 'Cupid's bow' in the top lip, which is generally fuller than a man's. In natural lighting, the top lip is usually in shadow, with light reflecting on the lower one.

The most enlightening thing I have seen in relation to drawing the face was a time-lapse film of a baby growing in the womb. It showed how the facial features grow and form out of one another, the ears growing like a flower's petals unfolding, skin forming around the eyes to become eyelids, the upper lip

created from folds of skin that were joined to the cleft in the roof of the mouth. Having seen this you will never again take for granted what may appear as a superficial line or fold in the skin. Although you may simplify them to a line or dot, it will be evident you understand how the contours it expresses evolved.

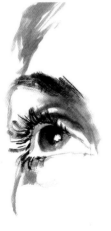

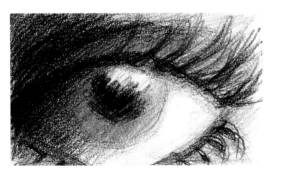

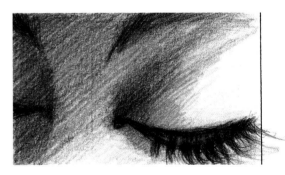

EYE SOCKETS
The eye is essentially a sphere in a socket. The muscles and skin that hold it must be evident, and the skin that covers the eyeball when it is closed must be visible within the folds when open.

SHADOWS AROUND THE EYE
Use the shadows around the eye to help create the shape of the eyeball. Even when the eye is closed the shape the skin takes on should describe what is underneath it.

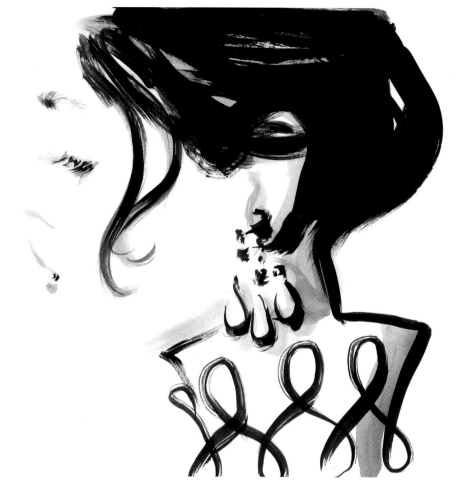

DEFINING FEATURES
It isn't essential to define every detail of each facial feature. Here, for example, the ear and nose are just shapes that help place the position of the head. The ear is defined by the shape of the hair around it.

DIRECTIONAL STROKES
Eyelashes grow from the ledge underneath the upper lid and on top of the ledge in the lower lid. Use this direction in the stroke of the brush or pen.

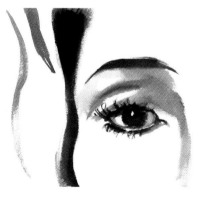

EYELASHES
Eyelashes can add drama and definition to a face. They are shorter towards the inside of the eye and longer on the outside.

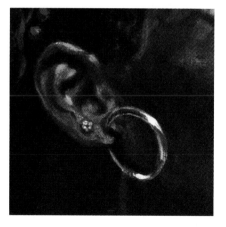

TEXTURAL CONTRAST
This ear is defined by the negative shapes around the folds of skin. The shiny metallic earring gives contrast to the texture of the skin.

Examine your own face

Heads and faces are sometimes described as inverted egg shapes with horizontal and vertical lines intersecting to indicate where the features are and how much you can see of them when the head moves. While this can be a useful simplification to begin with, it is good practise to examine your own face in a mirror to understand how the features are placed, to see the face as areas of flesh and muscle arranged over the skull, and understand how the shapes of its features change with facial expressions.

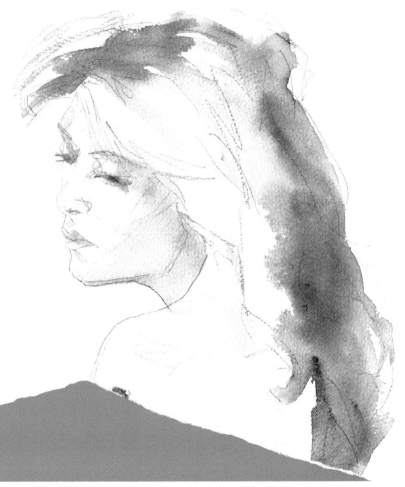

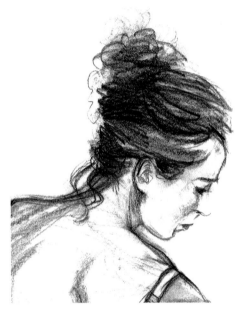

EXPLORATORY STUDIES
Some make-up mirrors have three hinged sections; use one to see your three-quarter and profile reflections. I used the top drawing to study where everything was placed so I could be more selective when I simplified it for the one on the right.

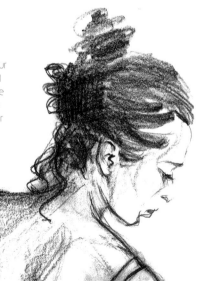

OVER THE SHOULDER
Drawing a head turning over the shoulder with the model's back towards you is a good exercise in placing the features on the face. The shape of the eyebrows and the centre point of the nose and mouth tell us exactly how the shape of the face and features come together in that position.

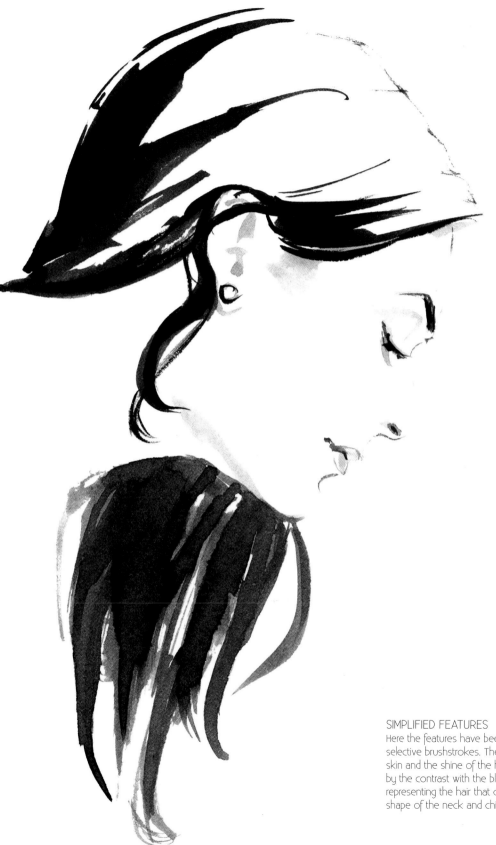

SIMPLIFIED FEATURES

Here the features have been simplified by a few selective brushstrokes. The pale silkiness of the skin and the shine of the hair are emphasized by the contrast with the blue watercolour representing the hair that defines the negative shape of the neck and chin.

Placing the features

Once you understand how the features are formed and positioned on the face, you will be able to define the position of the head by how much or how little you can see of the features. It is a natural tendency to try to equalize the features and make them symmetrical by making the left side of the face a mirror image of the right side. Check constantly for the differences between the two sides.

EXPRESSIVE LINES
This is an example of how expressive marks on the face can be, particularly the eyebrows, the lines of the forehead and the mouth. Note how the upper lips of men tend to be thinner than those of women.

STRONG LINES
The strong lines created by the hard-edged contrast in this oil pastel of the actor Michael J Fox help to create a masculine face. Note the square jaw and thin lips, and the suggestion of the Adam's apple.

Children's features

When drawing children's faces, remember that they are still very much a 'work in progress'. For example Daisy, right, is not yet old enough to have developed expression lines so has beautifully smooth skin. Although children's eyebrows are finer they often have full eyelashes which make their eyes look even bigger. Noses and ears are not fully grown, and so are not very prominent. Understanding these differences between adult and children's faces allows you to achieve an impression of youth, even through very few marks.

HEAD AND SHOULDERS
Although this sketch of Daisy shows just her head, I can achieve a more childlike impression by including a suggestion of her shoulder, as children's heads are larger in proportion to their bodies than those of adults.

FACE SHAPE
Children's faces tend to be rounder, with less visible bone structure. Their eyes are bigger in proportion and their mouths smaller.

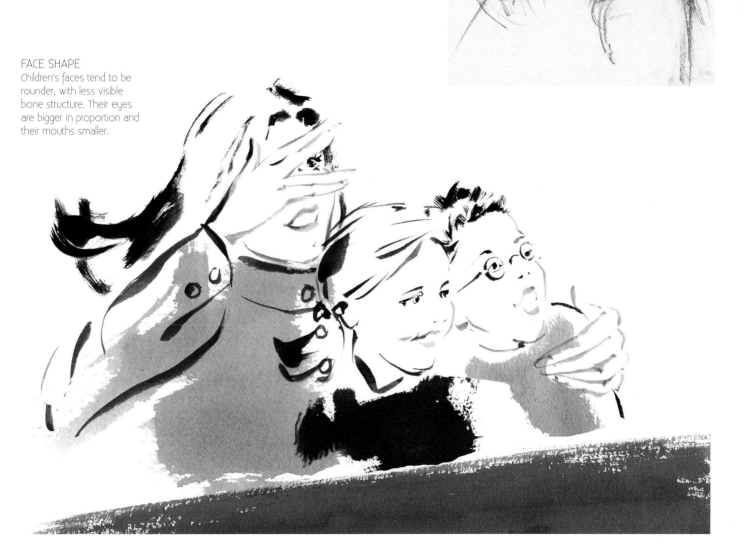

heads

Everyone's head is a different shape, so there is no magic formula for getting them right. When looking for the shape of a head useful clues are to be found in the contours made by the hair, and the position of the ears and eyebrows, for instance. Remember that the head has weight, and so it is important to note the way in which it is held, and its position in relation to the shoulders and neck.

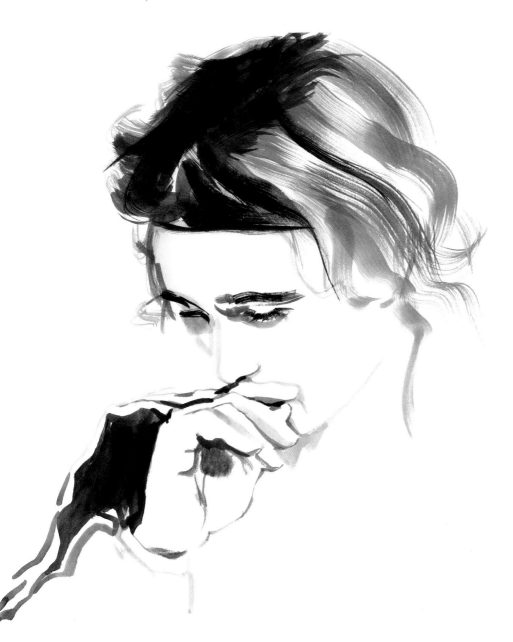

FINDING CONTOURS
The contours of this head are shown through both the hair and the headband. Each sweeping brushstroke describes the shape of the head, so you don't have to paint each strand of hair individually. Light and shade in the hair are used to give emphasis to the head's form. The eyebrows are an important contour line.

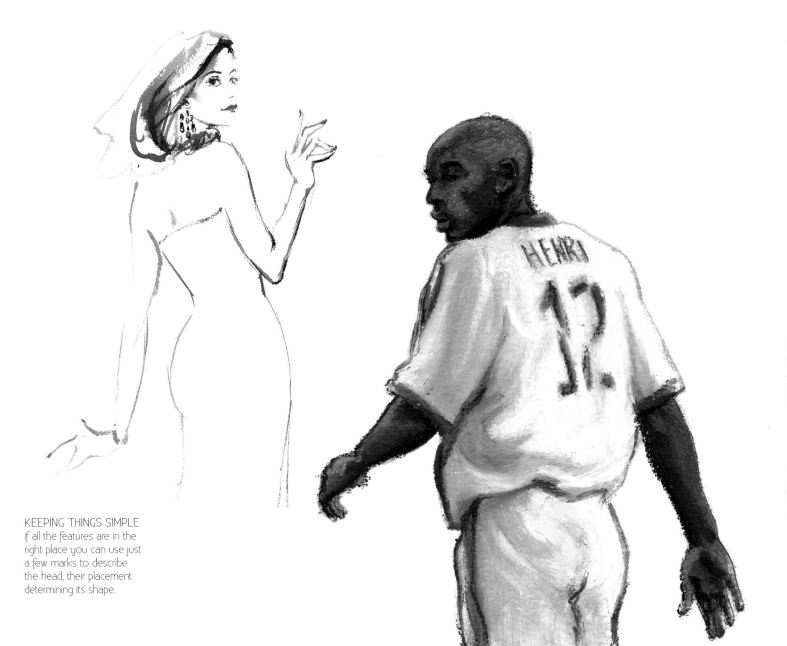

The head and proportions

The head is about one seventh or eighth of the height of the average standing human figure, but rather than use an equation as a foundation for your work, check this proportion only if you find that a drawing isn't working. A good exercise for getting the right shape of the head is to draw someone either without hair, wearing a tight headscarf or with their hair tied back behind their head. The shape and proportions of the skull will tell you about the individual placement of the features. By thinking about the contours of the skull, each mark used to depict the features will also provide the information about the shapes and forms they are set into and growing out from. Think about even the three-dimensional shape of the space inside a nostril, for example, to describe the shapes that form the nose.

REFERENCE POINTS
This is a good example of how, assisted by the way light reflects on a shaved head, you can clearly see the contours of the skull, the proportions and placement of the ears in relation to the eyes and their central point running down the middle of the nose and upper lip.

ANNIE
In this painting, on a seven-foot sheet of watercolour paper stretched on to a wall, the ink was left to drip randomly down the paper. This helped to give volume to the hair and a sense of drama. The more controlled shadows around the eyes help to hold the viewer firmly in her gaze, giving her a dominating presence. This is what the real Annie was like – larger than life and hard to ignore!

Women's heads

Any differences between male and female heads, as with the majority of the anatomy, will be a generalization and it is more productive to look at each person with an open mind. For instance, the shape and size of the head really depend upon a variety of factors such as age, bone structure and ethnic background. Even having been delivered at birth with the aid of forceps can have a bearing on the shape of a sitter's head. However, a woman's head is usually smaller than a man's, and her bone structure may be softer and lines more curved rather than angular. The forehead can be higher with a less prominent brow bone than her male counterpart. A woman's hairline is generally straighter, with a widow's peak being more common in the male. Also, a woman's cheekbones tend to be higher, and her jaw line is less severe and angular, than a man's.

HEAVY LINES
When describing the shape of a head, try varying the thickness and weight of the line. Avoid placing too much emphasis on outlines as they can flatten the image. Look for details that draw attention to the contours of the head within the shape. Here, a varied and descriptive line is employed for the parting and layering of the hair, which also suggests the contours of the forehead and skull.

Men's heads

Because a man's body tends to have more muscle in proportion to fat, this gives him a more angular appearance than a woman. His browbone will be more prominent and his jawbone more angular, whereas a woman may have more flesh on her cheeks, making her cheekbones appear higher. A man will be more inclined to have a cleft in his chin. He will also have facial hair, particularly around the mouth and jawline below the chin and on the neck.

SEARCHING MARKS
Drawing heads, like everything else, becomes more comfortable the more you do it. Make marks that are marks of discovery and searching rather than ones you feel you cannot change. Don't worry about making mistakes and don't judge your drawings and sketches – think of them as work in progress.

QUICK DRAWINGS
Draw whoever happens to be around you, wherever you are. Whether you are watching television or sitting in the park, always keep a sketchbook and pencil with you.

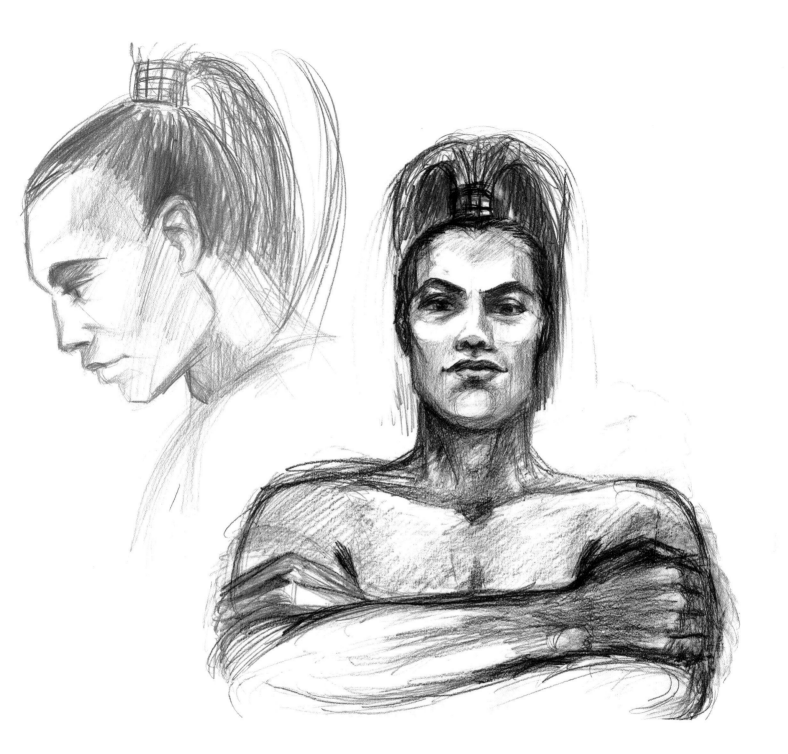

STRONG CONTOURS

This study of Vincent is an example of using the
strong contours of the skull and the facial bone
structure to convey an unmistakeably masculine look.
Vincent had beautiful, long hair, thick eyelashes and
a "Cupid's bow" shape to his upper lip, all things that
could have given him a more feminine appearance.

hands

Hands can be very expressive and reveal much about the model – not only whether they are a manual labourer or a ballet dancer, but about mood and personality, too. Whether they are open, closed, clenched, relaxed, holding on, or reaching out, hands have their own language that can become part of your drawing.

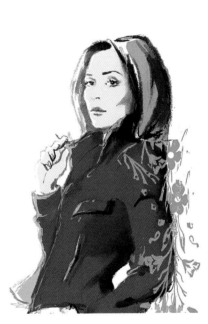

DESCRIPTIVE LINES
Use lines that express what the hand is doing. The fingertips here are drawn with a heavy line rather than with an outline around the hand.

Try to see each finger as an individual extension growing out of the palm of the hand. Each finger, for example, has three joints and the thumb has two. You do not have to define each of these separately, but once you are aware of them you will see shapes in the fingers and the spaces between them differently, which will help you define them and their character. Common mistakes when drawing hands are to omit some of the joints, to equalize the length of the fingers, and to bring the thumb up to join the first finger, whereas it should be about a finger's joint away. By using the differences between the lengths of the fingers and the shapes between them, you can add personality and expression to your drawing.

THE SIZE OF HANDS
Hands are bigger in proportion to the face than you may expect. In this image this is even more evident because the hands are the closest things to us. I have exaggerated them still more to add character to the pose.

EXPRESSIVE HANDS

Look for the negative spaces between fingers, as this can be a useful approach to drawing them. A hand can be portrayed by as little as the suggestion of fingernails and a few lines to describe knuckles and joints.

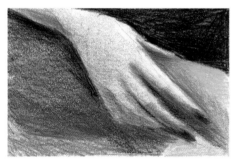

WOMAN'S HAND

This hand, drawn in coloured pencil, was from a storyboard showing a woman stretching to pick up the hem of her skirt. You can tell the hand belongs to a woman because it appears to be soft and the elegant way in which it is poised. The application of a little red nail polish helps!

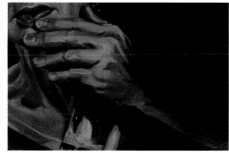

MAN'S HAND

In this detail from a portrait the hand is obviously a man's, with attention drawn to the muscles, ligaments and veins. An artist such as Lucian Freud would include these in a woman's hand as they are found there, too. But be true to the kind of painting you want to make and choose what you want to say.

HAND GESTURES

This drawing was part of an animation sequence for a commercial in which a woman imagines her boss to be a ferocious lion and has to tame him. The emphasis is placed on the finger-wagging gesture. The definition of the fingernails allows the fingers to be positioned without detracting from the movement.

feet

Feet are complex structures, containing 52 bones between them — about half the number of bones in the body — thus enabling them to be incredibly flexible. Feet are pivotal to a successful figure drawing. They must be convincing, even in the resting position, and be in proportion to the rest of the figure so that they seem capable of supporting the body and balancing its centre of gravity when it is in motion.

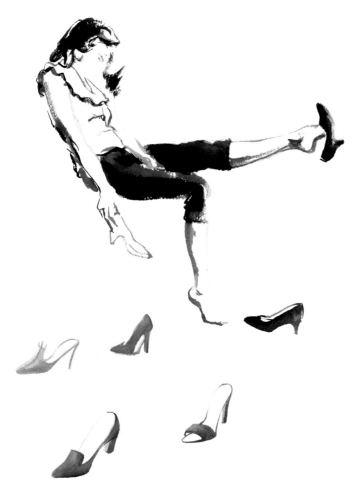

BALANCE
These images were part of an animated commercial showing a woman trying on shoes. You can imagine the toes on the feet concealed by shoes. In one image the shoe is balancing on the toes, in the next the foot is balancing on the heel of the shoe. Although the model is seated, her feet play an instrumental part in creating the movement of the poses.

ANKLES
The ankle bone is higher on the inside of the foot than the outside. Indicating this, even with the most minimal of marks, will help to describe the position of the feet in a simple and eloquent way.

Feet are not symmetrical and a drawing will look unconvincing if they appear to be, so it is important to differentiate between left and right. The little toe, for instance, is attached lower down the foot than the larger ones. The big toe is broader but shorter than the toe next to it and joins the foot lower down, almost in line with the little toe. Study your own feet with shoes on and off. Feet are straighter on the outside and have a slight curve inwards at the instep that corresponds to the curve on the top of the foot. The arch this creates is more pronounced when high heels are being worn. Feet do not mould themselves to a shoe shape; shoes will only look right if you can imagine the feet inside them.

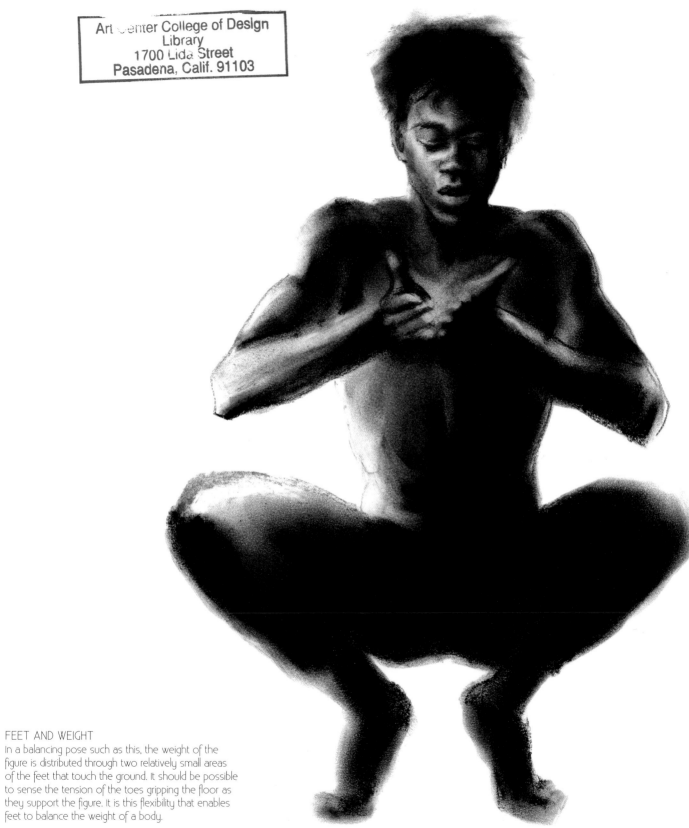

FEET AND WEIGHT
In a balancing pose such as this, the weight of the figure is distributed through two relatively small areas of the feet that touch the ground. It should be possible to sense the tension of the toes gripping the floor as they support the figure. It is this flexibility that enables feet to balance the weight of a body.

language

The subjects of a drawing, whether alone or part of a group, do not exist in a vacuum. There is always a story to be told. Who are these people? What are they doing? Why are they doing it? What has just happened, or what is about to happen? The body language of the subjects answers these questions.

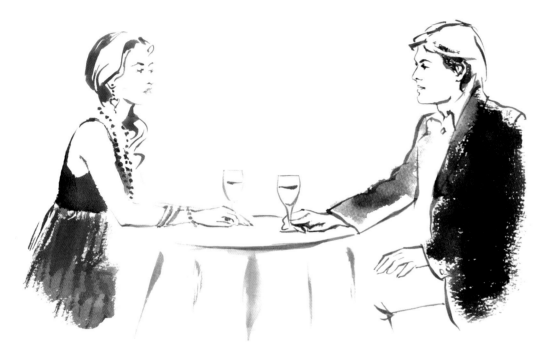

HUMAN CHEMISTRY
Faces, hands, posture and attitude all influence the chemistry between figures in a drawing. A subtle shift in emphasis can change what was, in the first image (left), a confident and relaxed meeting into one that is more intriguing (below).

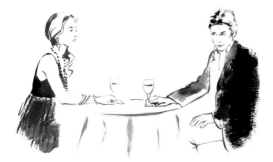

By placing two figures together in one image you will create a body language between them, even if each is unaware of the other's presence. In the main image, above, the characters are looking right at each other, sharing a glass of wine and a relaxed conversation. It was commissioned as part of a television commercial but the agency felt the man was too confident and conservative. Only the head was changed to give the impression of a more awkward and quirky individual. Suddenly, even the manner in which the man grips the glass and the tension in his hands seems to alter, and the nature of the pair's conversation and relationship changes. A completely new narrative has emerged.

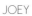

JOEY
This was an image for a poster campaign to promote the vocal artist Joey Ducane. It was developed from a series of images of him covering what is generally the most important vehicle for expression and language in a drawing — the face. The viewer is left to read the performance, like an exaggerated mime, by the drawing of his contorted figure.

Conveying a story

The overall impression of a figurative image – the story that is conveyed – is often told through body language. Gestural strokes can help to emphasize this story and communicate it in its purest form. Bertrand Russell once said that it is easier to communicate a complicated idea in complicated language that only a few people will understand than to convey a complicated idea in simple language that everyone can understand. It is the same with painting body language. Aim to make each stroke not only absolutely essential but also completely understandable.

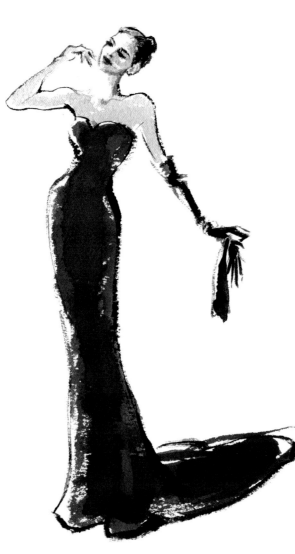

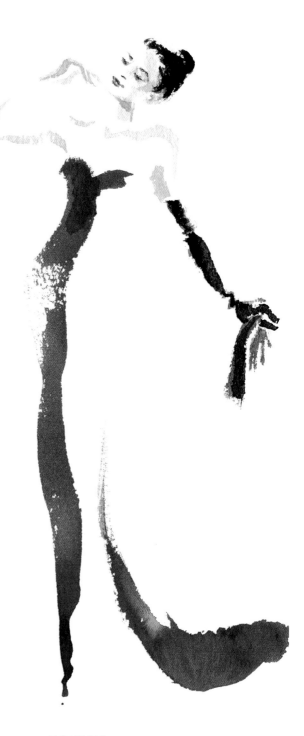

EVOKING ATMOSPHERE
This was the initial design to promote a perfume. The packaging was scarlet and the aim of the image was to evoke the atmosphere of Christmas. The figure had to reflect the perfume through her personality and in the way she is painted. So she is shown as a sensuous, sophisticated woman with grace and style.

SIMPLIFYING
In this final image the woman is painted with a minimum of brushstrokes, giving her the appearance of being suspended in space. The marks contain her essence because of their intangible quality, much as the memory of someone can linger, like a perfume perhaps, once they have left the room.

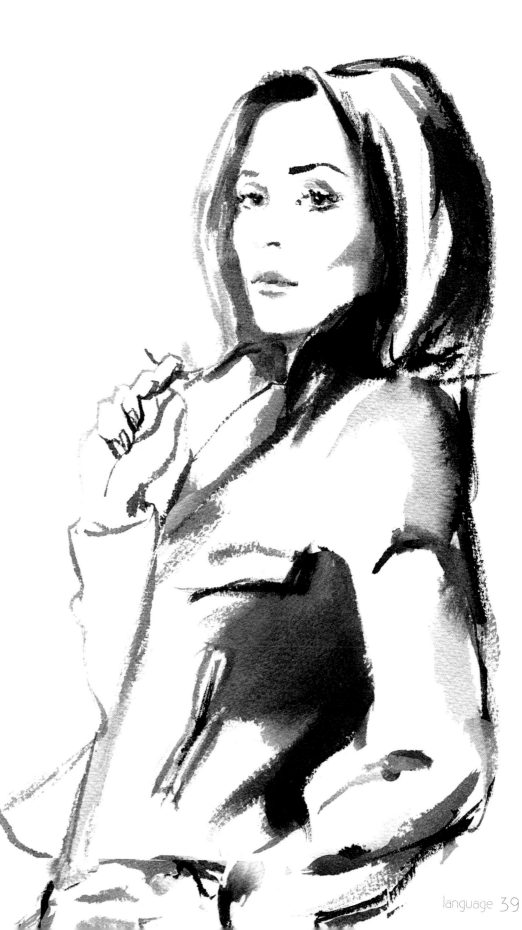

ATTITUDE
Body language defines the attitude of this woman in a poster campaign for an American shopping mall. We see that she is independent and fashion conscious, that she knows what she wants and where to get it — and before anybody else. It is her body language that tells us this. She is ahead of us, looking down at us. Her pose is one of defiance and hautiness. The eyebrow is made with one swift, gestural brushmark and draws attention to these qualities.

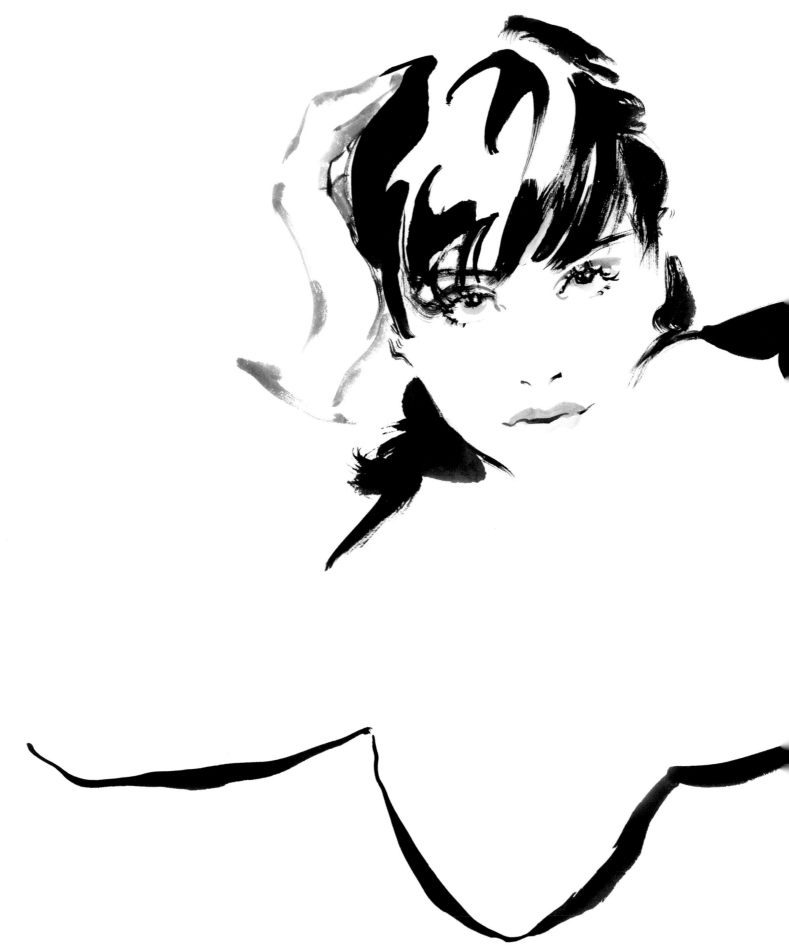

STYLE

It is a well documented fact that if you ask three people who have witnessed the same event to recount what they saw, you will get three very different accounts. It is the same when painting the figure; how you interpret the information and your personal way of expressing it will develop into your own personal style. Whether marks are delicate, considered, vigourous or energetic, the finished work will show what you have seen in the unique way you have seen it.

Inspiration

Look closely at the things around you, be curious and allow yourself to be surprised. Inspiration comes from anything, not only visual, but from music, dreams, fantasies, travel, problems or something inside you want to get out and understand. Keep a diary, sketchbook or scrapbook to make a note of things that mean something to you. For the commercial artist, there's nothing like an impending deadline to inspire you!

A field of poppies was the starting point for the sketches of these figures. First I was struck by their colour and texture, which reminded me of silk crepe de chine and its light, floating quality. When a breeze blew through the field, it became like a giant piece of rippling silk with flowers painted on it – or so it seemed to me. Poppies have long been associated with the Orient and with opium. It is this dream-like hallucinogenic imagery that was the inspiration for the painting of Lydia (page 97) where she appears as if from a dream in a billowing silk dress drawn out of a field of poppies, which turn into scarlet butterflies as they fly off into the distance and back into the dream.

SOURCES
Taking photographs or using the Internet can help you to record subjects that you find inspiring. I gathered inspirational items on a moodboard, shown on page 96, before starting the final image.

New directions

These images show how inspiration (in this case the light) can sometimes come from your own paintings to create new directions for your work.

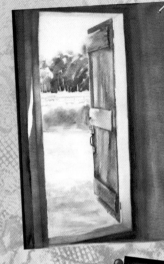

QUALITY OF LIGHT
On seeing this doorway, painted from life, I was struck by the sharp light outside and the blue quality of light inside.

LIGHT AND SHADOW
The bright light reflecting on this windowsill is created by painting the dark shadows inside.

LIGHTING INSPIRATION
To make an object appear appear to have bright light reflecting on it, it is essential for the rest of the image to be dark in contrast. The lighting in the images of the window and doorway done from life, shown on this page, provided the inspiration for these sketches from the imagination.

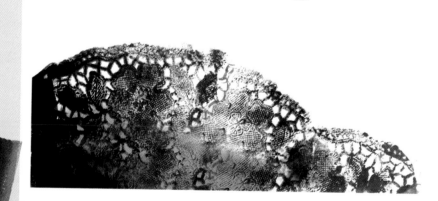

FRESH EYES
When I was growing up my mother would always put paper doilies under the cakes at teatime. They seemed equally absurd and adorable to me, and so I kept some in a scrapbook to remind me of her. And then it occurred to me that the doilies may have another use; I used one to print paint onto paper to create the lace appearance of this dress and the headband in the hair.

observation

Sketchbooks are a good way to make quick, drawn notes about things you have observed. You can also use a camera, but just the act of holding a pen or pencil to the paper can concentrate the mind on what it is you are really looking at, so you can edit out the rest. A camera has the advantage of capturing the whole scene, but photographs may not remind you what your original observation was about.

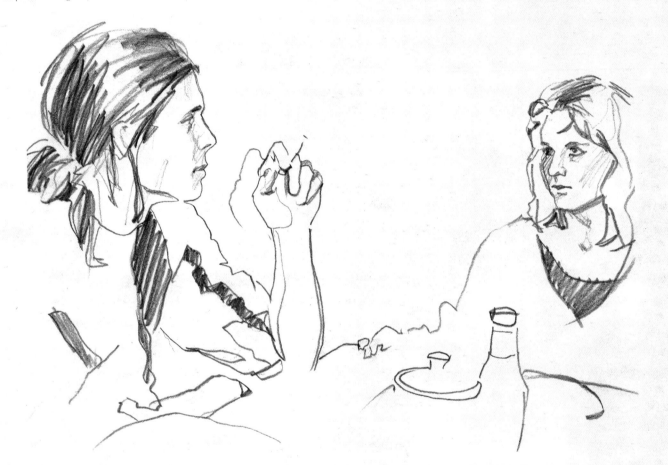

There are always going to be moments when you see something that you want to make a note of when you find yourself without a sketchbook, pencil, camera, or even a napkin or envelope. If this happens, try to make a quick sketch from memory as soon as possible. It could just record the light, the movement and the figure the most basic of marks. But however simple, this note will help you, when you have time, to refer to that moment that struck you and what was special about it. Your sketchbooks and reference pictures, notes and anything you have collected will become tailor-made by your personal observations.

MOVING SUBJECTS
This sketch was done at the breakfast table one Sunday morning during an animated conversation, so the heads and hands were constantly moving. I used an unbroken pencil line in some areas, not to create an outline but to concentrate on the contours as though I was drawing over the subjects and not on the paper. This allows you to keep your hand and eye moving with the image.

LAYERING DRAWINGS

These pages from a spiral-bound sketchbook record the comings and goings of the bustling canteen at Parsons School of Design, New York. I started by drawing the people by the farthest wall from me on a page at the back of the book.

BUILDING PLANES

Then I built up the image by drawing closer figures on the previous page and then cutting around them. The scene was gradually built on the right hand page, plane by plane, as each drawing is superimposed onto the one beneath it. On the left hand side another image is created from negative shapes and cutouts.

FOREGROUND FIGURES

People, tables and chairs continue to be built up as they appear closer to the foreground. These sketches could go on for ever, mutating and evolving, as long as people kept coming and going in and out of the canteen.

models

Everyone is a potential model: friends, family, strangers in cafes, parks, libraries, train stations and bus stops. The more people you draw the greater your knowledge of the figure will become and the material you accumulate will become increasingly comprehensive. Don't be shy about taking your sketchbook out – people are usually flattered when they see that you are drawing them.

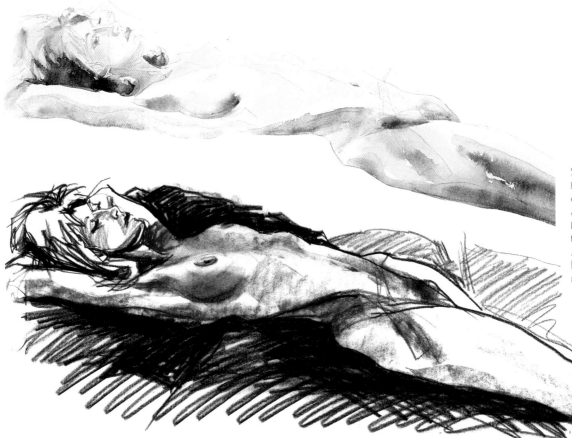

SHARED MODELS
Five of us met up regularly each week at a friend's flat and split the cost of hiring Rose, a life model we found through a local art school. As you get to know a model better, your drawings take on more of their personality.

WORKING QUICKLY
While the model held a long pose for artists making oil paintings, I made a series of quick studies. Drawing quickly forces you to work over the whole image instead of on small areas one at a time.

If possible, go to a life drawing class that will set you challenges and enable you to try new approaches and expand the way you work. Alternatively, you can set your own challenges and explore other avenues by experimenting. As soon as you get comfortable working at a certain size with a particular brush or in a particular way – change it. If you can't get a friend to pose, use a mirror, or take a sketchpad to a beach or swimming pool, or hire a professional model and split the cost between friends. Take turns to set the poses and at the end of the session lay the work on the floor to discuss what you have done. Include the model in the discussion; no-one in the room will have a greater knowledge of how each pose felt.

darkest tone

medium mid-tone

light mid-tone

lightest tone

Here an A2 charcoal
drawing didn't work, so
at a later date I tried to
recreate a similar pose from
memory using watercolour.
It is still not right, but I will
keep on trying

LIFE DRAWINGS AS STUDIES
Not every drawing or painting you start will
become a finished work. View each life
drawing as a study, rather like the workings-
out made to solve a mathematical problem.
Drawing from the model is an organic,
learning experience and one that you will
never finish; there is always more to learn.

SIMPLIFYING TONE
The contours of the model's
body in this pencil drawing
(far left) have been simplified
into four tonal shapes to
allow the ink used in a
subsequent series to be
applied in a more random
fashion (near left).

SHORT POSES
Start with lots of short poses of the figure in motion. This helps you to loosen up and helps your model to relax. If you are drawing a nude, take the opportunity to understand anything you find puzzling about a clothed body.

TAKE RISKS
Don't stick to the path you know – try a new route. You may get lost several times, but you will discover new things you have never seen before. Try drawing with your left hand, if you are right-handed. Or draw without looking at the paper.

A good model

A good model is one that is not only able to remain still and hold a pose for extended periods, but confident, inspirational and at ease with what they are doing. They can sense the kind of pose an artist wants, and make unusual positions and movements look natural. As with actors, it is not just down to beauty or a particular kind of physique, but character and confidence. A successful figure painting is a team effort between the artist and the model. Make a quick sketch or take a photo if you fleetingly see someone who would make a good composition, and recreate the pose with a model at a later date.

WORKING FROM SKETCHES

Figure drawings don't necessarily have to be made from a model who is present. The image on the far right was based on a number of quick sketches of my friend Jade that were made some time earlier. I was given a photograph of the front view of the peach dress on a different woman. By combining the information from drawing Jade and the dress the client wanted, I was able to make the finished composition.

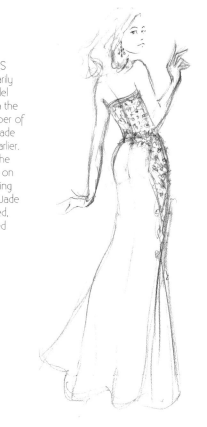

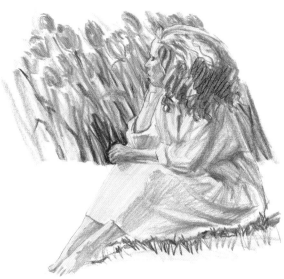

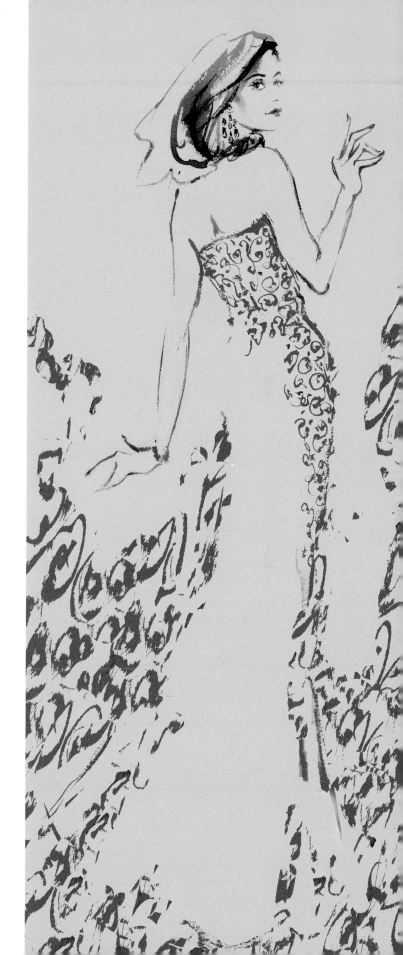

WORKING FROM PHOTOGRAPHS

Photographs can be an excellent springboard for compositions. In the absence of a model, I made this oil pastel sketch after taking a friend to Regent's Park to see the tulips and asking him to take a snapshot of me in front of them.

media

I don't use an enormously long list of different media. I have my favourites and by combining them they seem to provide almost infinite variation. I love art shops — they are like Aladdin's caves or seductive souks overflowing with sumptuous rich colours, powders, papers and brushes — I love watercolour brushes. I'm easily tempted to buy new products, but still come back to the few listed here. So try everything and make your choices; but remember — when using any medium it will always be more expressive to use it with your whole arm and shoulder and not just with your wrist and hand!

Pencils

Pencils are incredibly versatile and easy to carry around for sketching, and come in many hard and soft varieties. I usually use a 2B for quick line drawings and a softer 4B or 6B for tonal drawings. Keeping the lead sharp enables you to vary the pressure and thickness of your marks by drawing with the lead at different angles to the paper. Electric sharpeners are brilliant tools and now you can get small battery-operated ones that are more portable. Otherwise a penknife is the old-fashioned favourite. You can also use graphite sticks for covering large areas — again the softer variety is better.

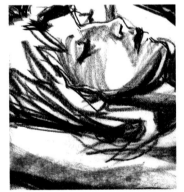

Charcoal

Charcoal comes in compressed, willow and vine varieties. Vine charcoal is easier to build up an image with and dark areas can be pulled out with compressed charcoal, which is stronger and blacker. Charcoal can be used on its side to make broad and textured marks and can also be smudged and blurred with fingers or a rag. Try taking a kneaded eraser and moulding it to a point so you can rub small highlights back into the charcoal. You can use cotton buds and card rolled into a sharp point as smudging tools, too.

Extra-thick aquarelle pencils

These jumbo pencils are perfect for covering large areas and big drawings. They can be used like soft pencils, but because they are so thick you can use your fist to draw with them and make bold and sweeping gestural marks. They come in a range of colours and are water soluble so you can take a large sponge or brush and paint right into the drawing, which will add another dimension to it.

Coloured pencils

I prefer the soft watersoluable variety. Like the graphite pencil, they are more versatile if you keep them really sharp. You can use them very lightly and then build the image with directional lines, laying colours over one another. As with watercolour, the paper is the white, so work from light to dark. Create subtle washes by using water on a soft brush lightly over the pencil.

Soft pastels

These extremely soft and powdery pastels are made from a compressed, clear, Chinese clay called kaolin. They can be used best by breaking them into different lengths and using them on their sides to pick up the texture of the paper. They can also be crumbled into powder and smeared with a rag to create transparent, dry washes that can then be drawn into.

Oil pastels

These have a fantastic painterly quality and, applied thickly, they appear three dimensional, or impasto. A hard brush or rag dipped in a little turpentine can be used to soften and blur the edges or blend colours. As with oil paintings, build the colours from dark to light, adding the highlights after the darks. You can use a scalpel to scrape off colour and smooth it on.

PENCIL TONAL DRAWING

I first blocked out this image using a 2B pencil in a very loose 'scribbly' way. I then started to tighten up areas I wanted to emphasise with a 6B using it on its side rather than the point. Finally, I used the point of the 6B to pick out and define the areas of shadow where I wanted them to have sharp edges.

Watercolour

Watercolours, which come in tubes or handy blocks that are easy to carry for on-the-spot sketches, can be used to build up colours using washes. Build from light to dark – the more dilute the colour, the more transparent it will be. Use no more than three or four washes or colour becomes muddy. When applied to wet paper the colours bleed into one another to create the most fabulous patterns and textures. Watercolour is difficult to control but looks best when it appears to be spontaneous; sometimes it is a question of accidents being better than anything you have planned.

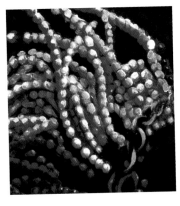

Acrylic

Acrylics are great to use on canvas or board that has been primed for use with water-based paint. You can use it thinned down with water and also more thickly, like oil paint. Unlike oil paint, though, it dries quickly and you can't paint back into it once it starts to dry, but dry layers can be painted over, and it is a fantastic medium for doing large or small paintings when you want to use rich, opaque and transparent colours on canvas.

Inks

Ink is fantastic to work with and my favourite medium. I use them like watercolour and sometimes combine the two. Ink is more concentrated, and can create a luminous and jewel-like quality. As well as using a brush or pen, try dipping an old toothbrush in ink and running a matchstick over the bristles to create a speckled effect.

BUILD A LIBRARY OF MIXED MEDIA TEXTURES
Paint discarded scraps of watercolour paper in different colours and varied consistencies using a range of media. When they are dry, paint next to and around them, and sometimes overlap them with another medium. Keep the shapes random and abstract. Use pastels only on top of dry paint.

These figures began as pencil sketches, which I simplified into ink line drawings and scanned into the computer before filling each area with colour in Photoshop. To fill areas in this way, it is best to make the drawings in ink because the computer only fills areas with a closed, unbroken line. Pencil lines may look unbroken but once scanned they are shown to have tiny gaps. The target was created using the ellipse feature in Photoshop.

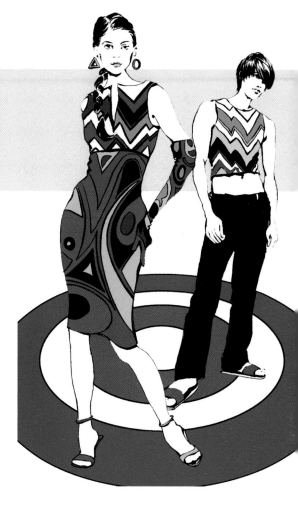

Gouache

Gouache can be used for painting flat colour and is opaque when dry. It is best to mix the amount you will need at the start, as it is tricky to mix more that will match perfectly. I like to squeeze gouache colours on to a palette with a small quantity of water, dipping the brush in a few colours, and then experimenting by mixing them on the paper as I paint to create an opaque blend of colour.

Paper

I use animation or layout paper for sketching because their transparent quality allows me to see previous drawings underneath. I use cartridge paper for brush or pen and ink, but mostly I use watercolour paper with a rough surface because I like to use texture in my work. Having said that, I will use any paper that is handy at the time, including printer paper. As I use so much cartridge and watercolour paper, I keep a few spare rolls in case I run out. Consider using coloured paper, such as this coloured Ingres paper.

Software

Computers have revolutionized the way a commercial artist works today. I learnt to use only the most rudimentary functions in Photoshop and for the way I prefer to work, which is always by painting or drawing and then to use Photoshop. For me, it is a useful tool in addition to the other media, but not a substitute. New programs are being developed all the time, and if I see something I want to experiment with I will have to learn how to use it – although spending too much time sitting at a computer might take all the fun out of working!

palette

There are an infinite number of shades and combinations of colours. Painting the figure, like anything else, is a question of observation and selection. The colours in the subject you are painting are a result of a variety of factors, such as light sources, reflections, atmosphere and mood. Consider all these elements when choosing a palette. Colours do not have to be literal. Make them your own personal choice.

RECORDING COLOUR
On Praslin, in the Seychelles, light appears a different colour than it does in the UK, so I took a photograph of 'Nonna's boy' on holiday, recording elements I could return to later. I also made watercolour notes on site since most cameras and printers can't be relied on to reproduce subtle diifference in the light qualilty that make a place unique.

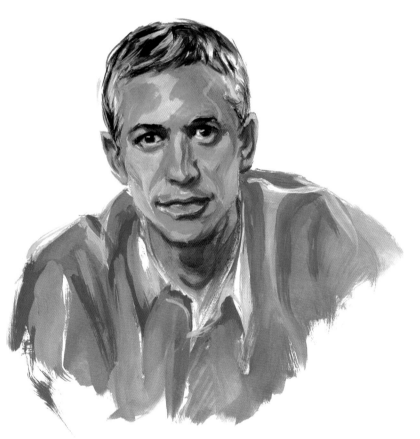

COLOUR UNITY
Colours in this gouache of the sports presenter Gary Lineker have been mixed on the paper with a brush, making the colour appear more lively. Using tones from the shirt in his hair and face helps the colours work well with one another in a unified palette, making the image appear more animated.

A wide variety of colours can be made from a few tubes of colour. Changing the proportions in which they are mixed and how they work in relationship to each other in the composition can create the impression that a much wider range is being used. Rembrandt's paintings, for instance, employ relatively few colours interspersed with a few bursts of carefully placed, vibrant colour. It can be surprising which colours need to be mixed to make a composition work; it isn't always down to the most obvious option. Try things out, remembering that palettes are made from much more than the literal.

Hair and skin can be made up of several colours, but choose the one you want to be the lightest area, and paint this as a wash first

For highlights and lowlights in the hair, apply further layers of washes in the direction in which is growing

Create highlights by letting the first wash dry. Then wet the paper again, but leave the shape of the highlight until last and then allow it to get only partially damp. Then apply the darker colour and it will make a soft bleed into the highlight

Paint the different colours found in the skin by working on wet paper and letting the washes run into each other

USING A SMALL PALETTE
The palette used here is a small one: yellow ochre, ultramarine blue, rose madder, viridian, and burnt umber. A few colours can be used in countless variations of mixes. Black can be mixed from the blue, reds and umbers, and with watercolour white is simply untouched paper.

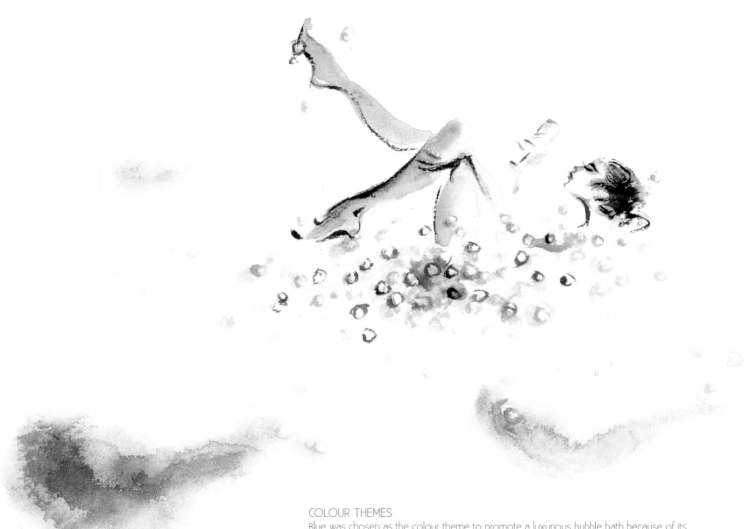

Warm and cool colours

There are more than 40 words in Latin for the colour blue so it is much easier to be specific if you are describing a particular shade. This is true in visual language too: the more variations you discover by mixing and experimenting with colours, the more articulate you will become when describing them. No colours exist in isolation in painting – they are all affected by every other colour around them. Change one colour, even the size or the shape of it, and they will all change.

As a general rule, cool colours will recede into the background and warm colours will appear to be closer to you or to be brighter. You can create the illusion of a very bright fabric or surface by putting a warm colour next to its complementary cool colour, such as a warm gold (yellow mixed with magenta) next to a cool blue-based purple.

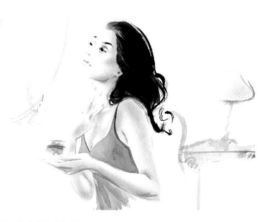

WORKING TO BRIEF
Some commissions have a list of criteria that the work must meet. For this image, for an animated commercial, it was a requirement to use the product's trademark aquamarine so I used a gold ochre and burnt sienna in the skin to add warmth.

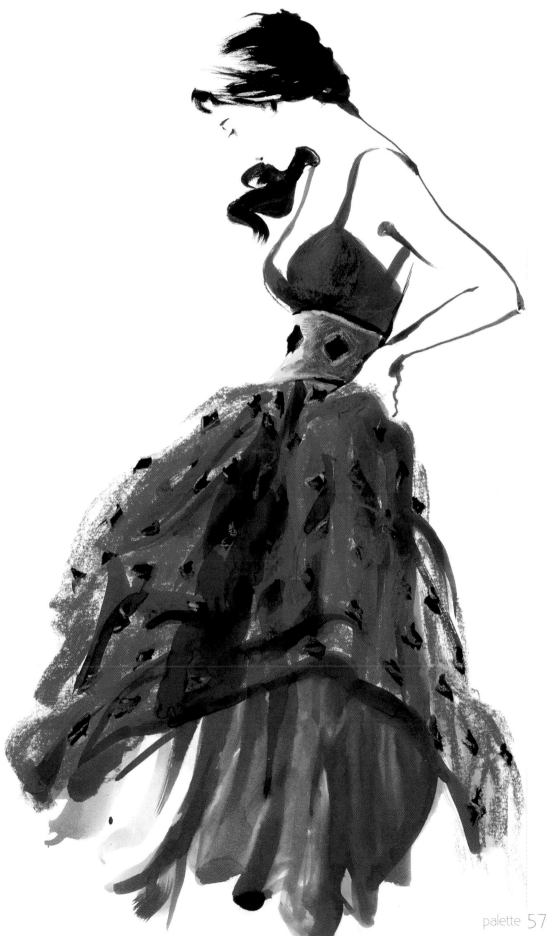

MIXING WARM AND COOL
The colour in this image is integral to the gossamer-like, floating textile of the dress. Magenta and gold pastel are applied over a watercolour base to create an illusion of transparency.

movement

There is movement to be found in any figure. Looking for movement in an athlete is one thing, in a static figure it is something else entirely. It has two aspects: the movement of a figure through space and the movement of space around the body. There are a variety of ways of bringing dynamism to your work – drawing figures in motion quickly will increase the vitality of your finished work.

BALANCE AND MOVEMENT
This golfer is at the end of his swing, at the moment when the momentum and force of the movement is at its peak. The aim is to show a sequence of movement in one image rather than to show one image out a whole sequence.

RESISTANCE
The clothes that an athlete is wearing will reflect the action he or she is taking. This footballer's rapid movement forces his shirt and shorts back onto his body.

Drawing figures in motion requires capturing the sense of what may be a long series of actions in just one image. With such a constantly changing scene, when working from life, it is important to work quickly with a few descriptive lines. By taking just a few moments to make a drawing, you will gradually become more confident about making marks that are about movement rather than anatomy, before moving on to make drawings that combine the two. The sense of movement of a figure can often come from the space around it. The context of the subject has a significant effect, in the same way as being on a train when the one on the next platform starts to move, leaving us uncertain if it is our train or the one next to us that is moving.

ILLUSION OF SPEED
To help create the illusion of speed, I have concentrated here on areas around the legs and the arms to find shapes that capture movement. By pushing out colour from the body the sense of an after-image is created, suggesting the space out of which the footballer has just moved.

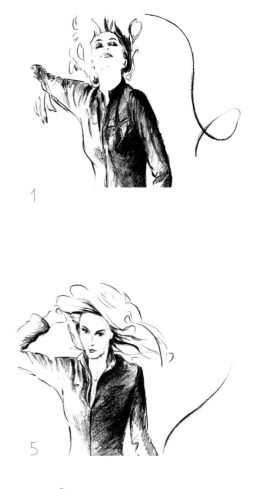

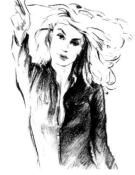

1

5

9

IMPLIED MOVEMENT
This image, from the middle of the series (image 6), has to indicate where the action started and where it is going to finish. The position of the hair and the whip imply the direction of movement as they swing from one side of her head to the other, and from the background into the foreground.

Using animation

These drawings are from a sequence of animation of a woman with a whip striking the air in front of her. The directional strokes of the whip as it draws downwards and the sweeping marks making up her hair create the illusion of movement. Live action on film is generally depicted at 25 frames per second, and in animation this illusion of real-life action is created by making a drawing for each one of those frames. As you can imagine, 25 drawings per second will show minimal variation between each drawing. But if you look quickly at the first image and then at no 6, and then at no 12, and repeat this back and forth, you will begin to see the movement. This is exactly what an animator does to create the illusion of live action. He will draw the starting point of an action and then, on a separate piece of paper, draw its conclusion, and then, between them, the middle of the action. He will continually flick between these images and from these create the images in between.

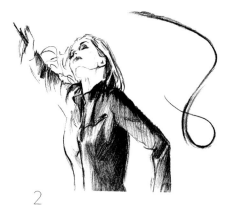

2

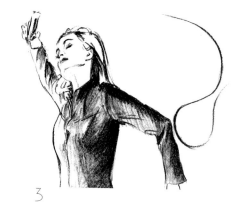

3

4

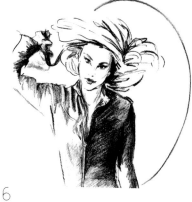

6

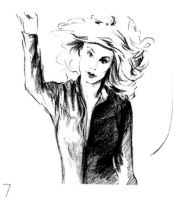

7

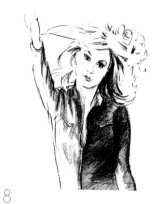

8

10

11

12

CREATING A SEQUENCE

If you pause live action on a DVD player, for example, the image will often appear out of proportion and distorted although you don't notice this when it is shown in sequence. Animation frames, too, when viewed individually may not look right as a still frame, but they work when in motion. Like a game of snooker, you must constantly have your eye on the next move and line up your next shot while playing the one before.

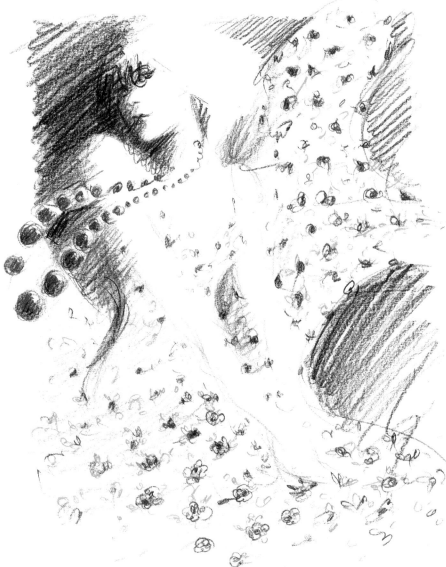

PERSPECTIVE
The animation then draws back to reveal the flowers to be part of the printed fabric of a dress worn by a woman who appears in a small section at the top of the page. The stylization and overemphasized perspective bring a dynamic edge.

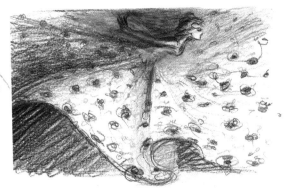

MOMENTUM
For the final frame, the imaginary camera has tracked out to further reveal the woman as she sweeps in one direction while the fabric of the dress is a sea of pleats moving in the opposite direction, thereby creating a sense of momentum.

Visualizing an idea
This image is part of a short animated sequence for a website. This part of the colour storyboard is not just about movement but a visualization of an idea for the client in which the images weave in and out of each other. The necklace has been exaggerated to create a sense of movement; the beads are enlarged as they come closer to the viewer, and are drawn with more intense colour. The beads also give the impression of weight, in contrast with the light, billowing dress. The woman's face is almost incidental; the emphasis is on the dress. The beads and the directional lines depicting the background all combine to suggest motion.

IMAGED MOVEMENT

To recreate an image for which you have no reference, pencil is an ideal medium to help you find your way and work out how to make figures and movement work. These pencil sketches were an attempt to recreate an imagined moment from Wuthering Heights. Ink, on the other hand, allows you paint the complete form with just a few sweeps of the brush.

LOOSENING UP

The act of repetition — these are a few of more than 30 such drawings — lets one relax, loosen up, become less inhibited about mark-making and more familiar with the subject, although the first drawing may still turn out to be the best. The resolved image features only the hands and face of the woman, but her form and the way she is moving is communicated through the sweep and folds of her cloak.

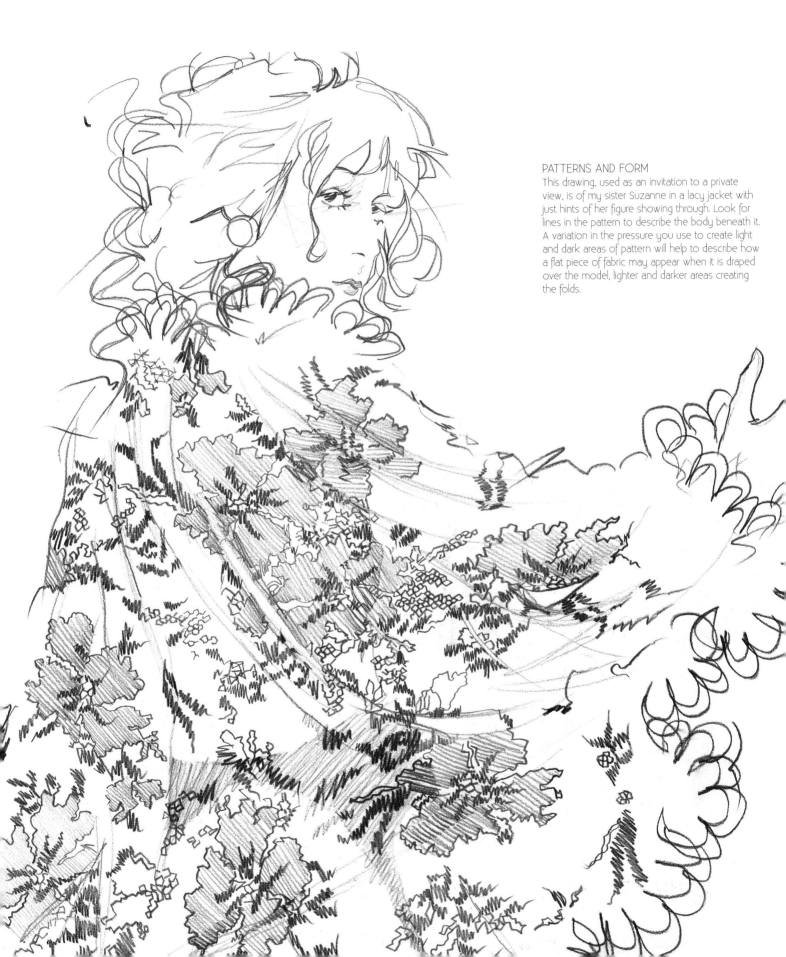

PATTERNS AND FORM

This drawing, used as an invitation to a private view, is of my sister Suzanne in a lacy jacket with just hints of her figure showing through. Look for lines in the pattern to describe the body beneath it. A variation in the pressure you use to create light and dark areas of pattern will help to describe how a flat piece of fabric may appear when it is draped over the model, lighter and darker areas creating the folds.

clothing

When drawing clothes, remember that there is a body within them, and that although they have a weight, texture and shape of their own, their appearance will always be affected by that body inside them. Unless you are trying to create a pattern for a seamstress or pattern-maker, the drawing doesn't have to be literal. Clothes have more to do with the impression they make, the story they tell and silhouettes they create.

BENEATH THE CLOTHES

When I was a postgraduate fashion student in New York we had an inspirational tutor, Sandra Leichman. She would put the model in the same pose twice; first nude and then clothed to show us literally how the clothes related to the body within them. This is the first requirement for fashion students, but it is an excellent exercise for us all.

As well as thinking about the body beneath the clothes, it is useful to approach the act of drawing of a clothed figure in the way you would make a quick, spontaneous life drawing. The marks you make as you search for the form will help to give volume and movement to the clothes. You can always apply tone and details, but it is the searching marks that you make, although not visible on the fabric, that will give life to the image.

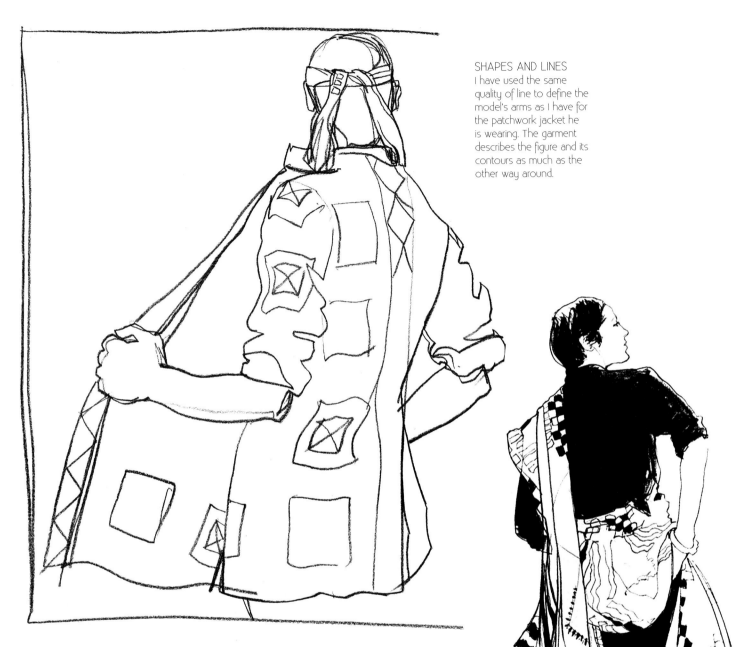

Creating fabric

Notice how different materials behave in their own individual ways. Even in the simplest of drawings you should be able to differentiate between a light fabric, such as chiffon or silk crepe de chine, and a heavier material, such as leather or wool. You can tell by looking at fabric, even if it is just on a hanger, that its cut dramatically affects how it falls or hangs. When placing the clothes on the figure the impression is of the silhouette, the weight and texture of the fabric and how it moves on the figure. You can select the details you want to accentuate depending upon what strikes you as important; there is no need to include everything. You can use the pattern on a fabric to create the shape of the garment or you can use the pattern only in areas you want to make prominent.

FOLDS AND PATTERNS
The folds in the material in this drawing are shown by the breaks in its pattern. The shirt and trousers are just flat charcoal – the lack of detail creates a more dramatic silhouette.

LEADING THE EYE
In this watercolour of Jade wearing a taffeta dress and petticoat, painted for an exhibition, attention is immediately drawn to the red shoes. The eye is then drawn along the legs to her head, which I have painted minimally so that the shoes remain the centre of focus. I experimented by adding red lipstick but removed it when it unbalanced the composition.

Characters and costumes

We make up our minds about a person when we first see them, professionally and emotionally, primarily by the way they look, deciding how we feel about them within seconds of meeting. A large proportion of how people appear is down to what they are wearing. So when choosing the clothes in an image or describing the ones you have been commissioned to use, remember they can help you to say a lot more about the figure in the clothes than just what their body looks like wearing them. Clothes, hair and make-up will all date an image since fashion changes so rapidly, but they also tell a story and your figures – like characters in a play – can be dressed, lit and posed to give them the appearance of the character you want them to portray. Magazines, fashion catalogues and the Internet are fantastic sources of information for clothes and accessories.

CLOTHES AND ENERGY
Wanting to depict a confident, go-getting 30-something woman for a cosmetics advertisement, I have shown her coat with a few strokes, the tie around her waist just a darker line, with an emphasis on movement and energy.

CAPTURING CHARACTER
I turned to the Internet to get ideas for these sketches for an animation for an airline. Even though I have used only a few lines, they are enough to capture the character of the clothing.

UNIFORMS
In this drawing for an inflight video, I needed to capture the character of the pilot as someone in authority who you could trust. The focus is on his uniform, which is painted in flat colour, with white gouache used to define the details.

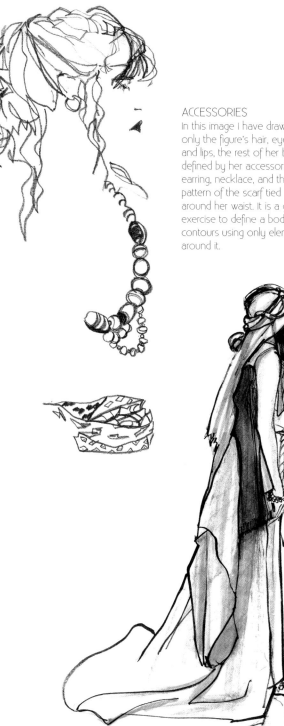

ACCESSORIES

In this image I have drawn only the figure's hair, eye and lips, the rest of her being defined by her accessories: earring, necklace, and the pattern of the scarf tied around her waist. It is a good exercise to define a body's contours using only elements around it.

PERIOD COSTUMES

These historical costumes from the Metropolitan Museum of Art, New York, were modelled in its basement but rarely go on show because of their sensitivity to light. The bustles, wigs, bows and petticoats change the silhouette of the entire body. If your local museum doesn't open its collection in such a way, try hiring from a theatrical costumier.

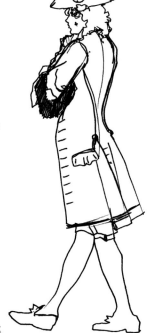

LAYERS AND FOLDS

This design was for a company wanting a logo on the theme of 'pilgrim'. So, far from making a fashion illustration, I have aimed to capture a brand. Only the foot, nose and arm are visible, and the shape is formed out of a jigsaw of layers and folds of material.

DECORATIVE CONTRASTS

The detail in the clothing shown here is intricate, with the seams, buttons, pockets and button holes creating a decorative contrast to the simpler silhouette and open lines of the legs and shoes.

hair

Anyone who has ever decided to have a makeover will tell you that a change of hairstyle is the single most dramatic change you can make. Hair frames the face and can completely change, accentuate or hide its features. The silhouette, texture, style and weight of the hair are all integral parts of the figure and the personality.

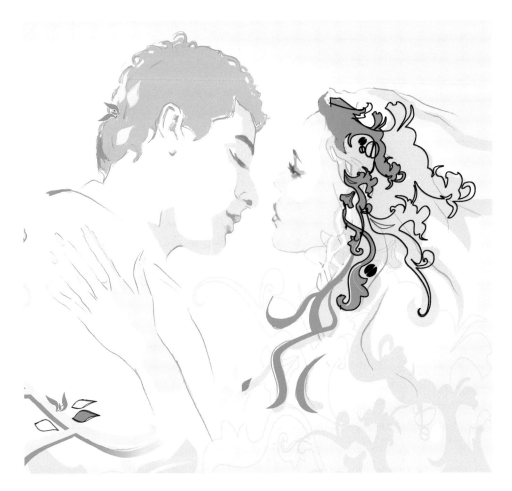

HAIR FORMS AND SHAPES
In this image for a coffee commercial, the hair had to incorporate elements of the decoration from the packaging. Even though we know that this is not hair, we can read it as such because the elements follow the form of the head, and take shapes that hair would.

The shape of hair

Look for shapes in the variety of planes and the patterns they create in the hair. Always keep in mind the contours of the head and the direction the hair is growing in. If the hair is long, use the contours of the neck and shoulders to show its volume, shape and how it falls in relation to them. Whichever media you use, try to keep the marks you make descriptive. They have to represent lighting and texture, too. For example, light will have more defined edges when it is reflected on sleek, shining hair but more diffused when it hits frizzy or Afro-styled hair. You don't need to draw every strand, but you do need to draw everything else about it: its shape, weight, volume and texture.

HAIR IN MOVEMENT

In this charcoal image, by using a variety of marks to contain the volume of the hair and by making them heavier on one side, the open areas appear lighter, so creating a floating-in-air quality that gives the image movement and energy.

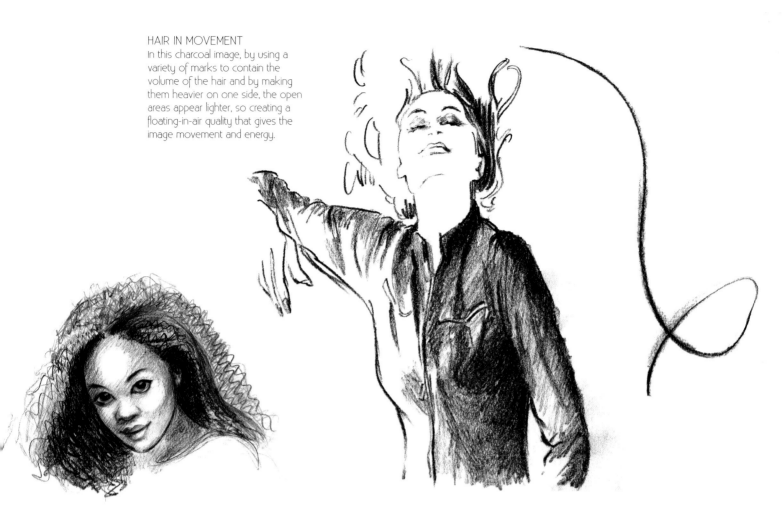

HAIR AND CHARACTER

The hair here is drawn with a mass of scribbles. I had no model to work from, as this was a character design for an animated TV series. My brief was to draw a mixed-race teenager with a 'rebellious streak'. A lot of personality comes across in a hairstyle; it only needs to change slightly for the nature of the subject to be altered.

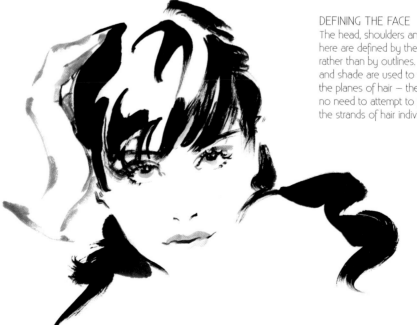

DEFINING THE FACE

The head, shoulders and face here are defined by the hair rather than by outlines. Light and shade are used to show the planes of hair – there is no need to attempt to paint the strands of hair individually.

detail

Details are often thought of as the last things to be added, after the rest of the drawing has been completed, like decorating a cake or putting the finishing touches to a room by throwing cushions onto a couch. But details can be the first thing that strike you about a person, so when you come to draw them, they should be the first things you think about. They should be integral to the drawing and not an afterthought.

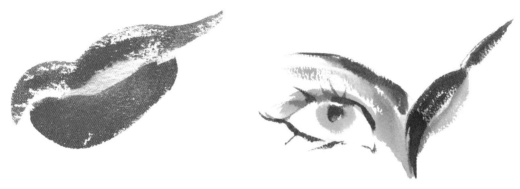

LIPS AND EYES
Lipstick can define the shape of the mouth – I have used a single brushmark to follow their shape as if sculpting them. When drawing eye shadow, try to imagine that you are actually applying it to the model as you are drawing it.

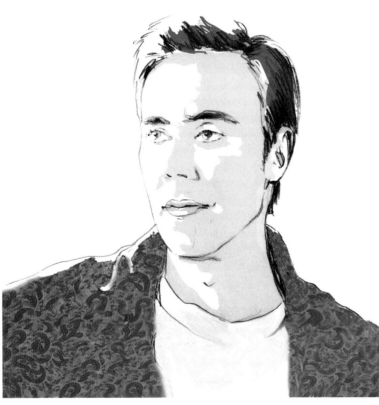

Integrating details

Before you put your first marks on the paper, consider which details you want to include in the image. Imagine how you will place them and, if you plan to use another medium, how you will integrate them, how the detail will work within the drawing, and whether you are adding colour or pattern or a separate decorative element. Always relate them to the whole image and make it work as part of it, not as an addition to it. Use the colour or pattern to draw the detail. Draw lips, for example, with the colour of the lips, not by adding colour. Details can also be used to balance the design of an image and for dramatic effect. A few well placed splashes of colour in an otherwise monochrome image will be much more effective than adding many more.

SCANNING MATERIALS
The paisley pattern in this image was applied by scanning a piece of patterned material and creating the shirt in Photoshop.

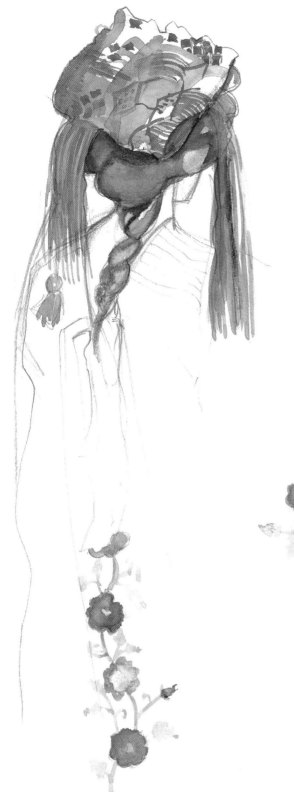

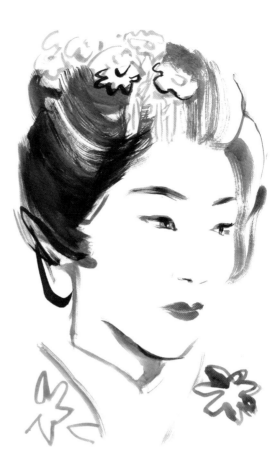

DETAILS FIRST
In both of these images, above and below, the decorative details, such as earrings, lips and flowers, were emphasised first in the compositions, with the rest of the image then designed around them.

COSTUME DETAILS
Little of the figure is evident in this watercolour sketch of a model wearing a costume from the Metropolitan Museum of Art, New York. Only details of the fabric have been picked out.

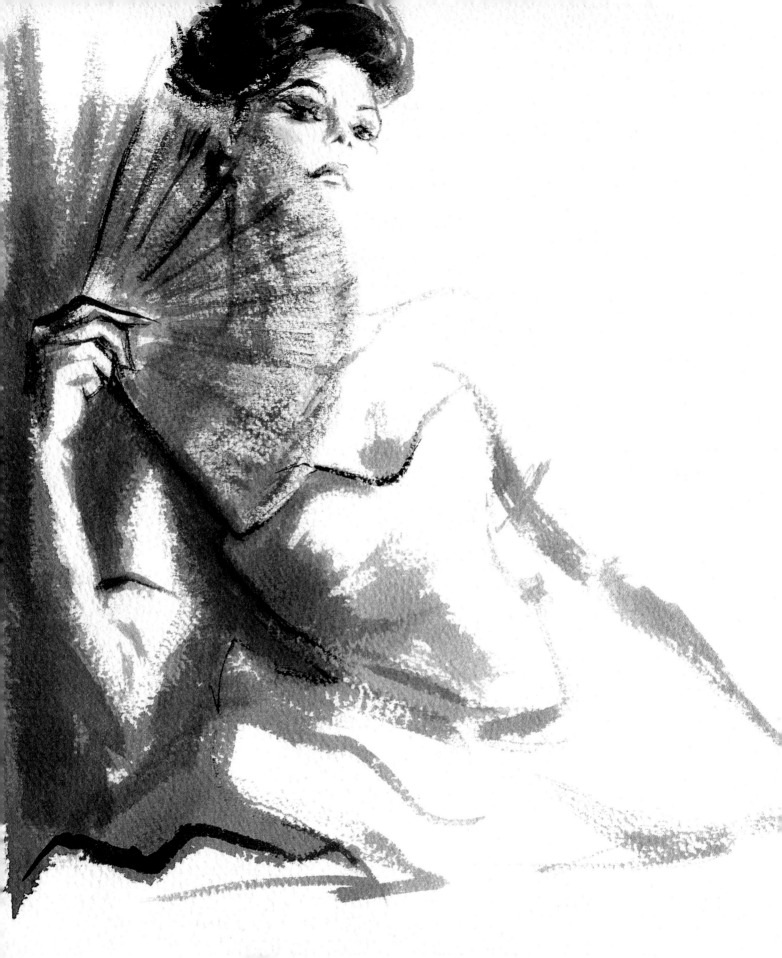

character

Character can be hard to define. It is more to do with personality than physicality. Paintings can successfully arrange all the features in the right position and the colouring, tone and posture of a person can be faultless, yet the resulting image may still not capture the sitter's likeness. Even some photographs are no more successful, as it is impossible to portray everything about the character in a fraction of a second.

KNOWING A SUBJECT
This elegant and composed woman could be a princess or a courtesan – as she is a stranger we have no preconceived ideas about her character. People tend to make decisions about their feelings towards people quickly, usually within seconds.

Making character visible
Capturing the character of a person is not about portraying what they look like, but rather about capturing the way they project themselves. This can be in all sorts of intangible ways, such as the way they move, the way they talk, and the way they make us feel about them. Capturing their character is about making those things visible.

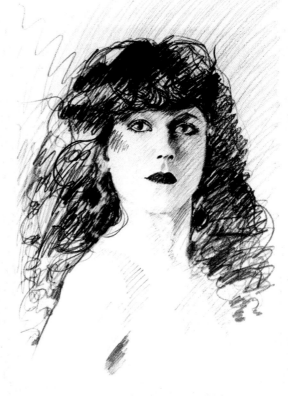

CRESSIDA
This portrait was done in graphite and colour pencils. Cressida has a bubbly and vibrant personality that alone is a challenge when aiming to convey it in a single drawing. The strength of directional lines and the speed at which they are made will help to put movement and vitality in to a static pose. It is much easier to stand up and use your whole arm and upper body when drawing like this.

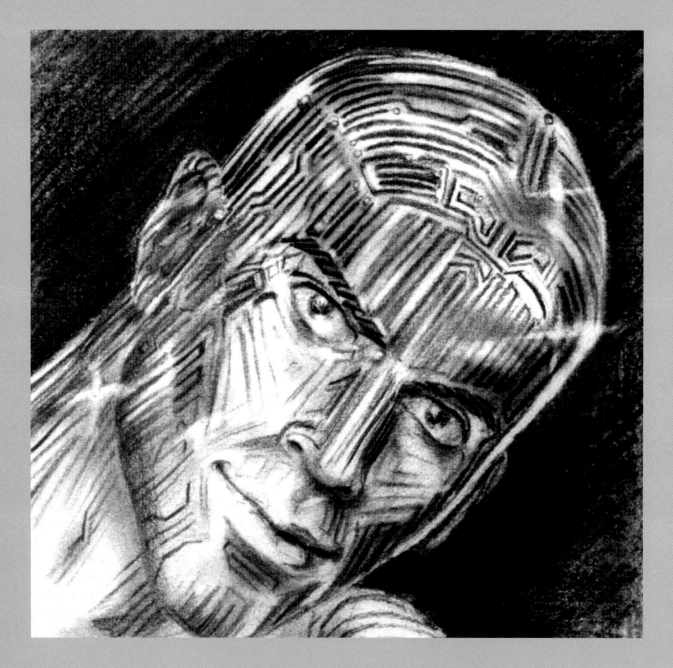

Capturing character

Think about how a caricature can convey a person's character to us in only a few selective and expressive lines. Examine your subject closely and find out what it is that gives them a unique appearance and how you could apply these to your image. This will not necessarily have anything to do with their physical appearance. Their age, race, sex, bone structure, muscle tone and other tiny details need to be considered to achieve a likeness, but it isn't guaranteed that this will capture their character. Imagine identical twins with different characters. How would you portray them? There is no formula to this. It may take many attempts; sometimes it happens quickly and easily, and sometimes it takes longer.

FACIAL EXPRESSIONS
This character, human in form but with printed circuits covering his body, was designed with an art director for a futuristic video game. The character of a person is generally communicated through facial expressions, even with an essentially robotic subject, such as this.

INDIVIDUALITY

I used a couple of iconic photographs by Mick Rock as reference for this image of Iggy Pop, who is known for his energetic live performances. One was from his early days, the other more recent. I wanted to show him as ageless, young and old at the same time.

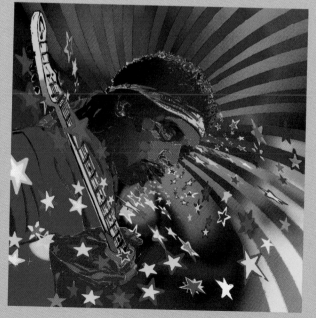

REFERENCE MATERIAL

In this detail from a bookcover I have employed the psychadelia of his era to portray Jimi Hendrix as the patron saint of guitarists, using rays of coloured light to suggest his halo.

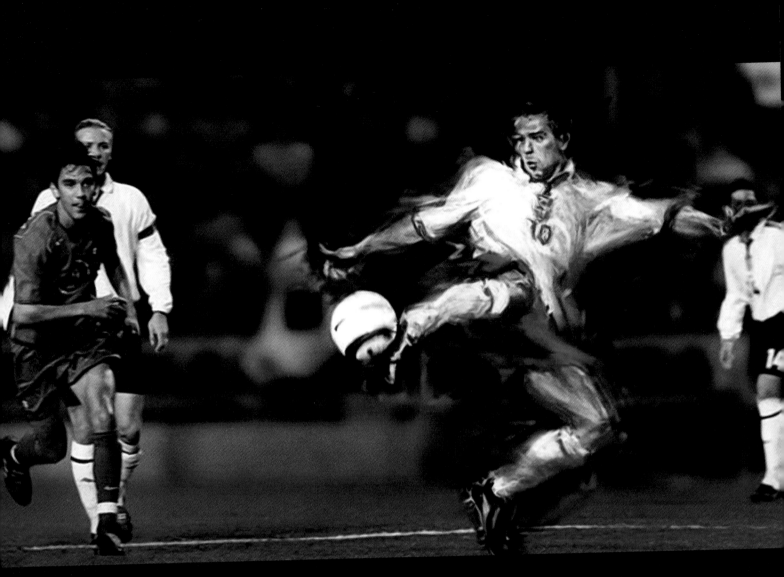

Focus and energy

This poster was part of the BBC TV campaign,
directed by Martyn Pick, to promote the Euro 2004
football tournament. Selected football stars had to
appear to have been painted by artists, but also to
be interacting with the other live action players on
the field. This image of England striker Michael Owen
was to be an oil painting and with it I attempted
to imply the energy and strength involved with
the movement through his body. I used intense,
controlled marks on his face to concentrate the
action on the way he is totally focused on the ball
and his control over it.

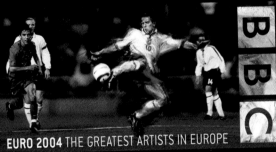

EURO 2004 THE GREATEST ARTISTS IN EUROPE

BBC

Live action storyboard

These drawings were panels from a live action storyboard I was commissioned to do for a pop promo. It was for a blues track called *Out of Focus*, written and performed by Mick Jagger, and influenced by blues legends, such as Robert Johnson. The intention was to portray Jagger as this same type of lone, enigmatic character.

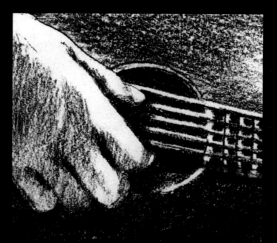

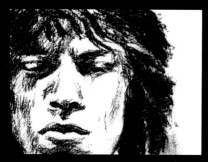

OPENER
This moody opening section of the video aims to draw the viewer in to his performance and his thoughts . . .

FOCUS
. . . through the simplicity of the acoustic guitar.

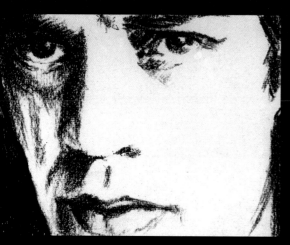

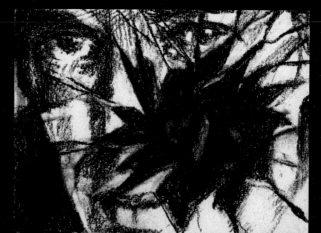

CHARACTER
Then we are drawn into the 'all singing, all dancing' animated sequence of the track.

PERFORMANCE
This section of the video shows him in an empty, dark monochrome room with a shaft of light capturing him alone on a bed, strumming the guitar . . . We are now focused entirely on him and his performance.

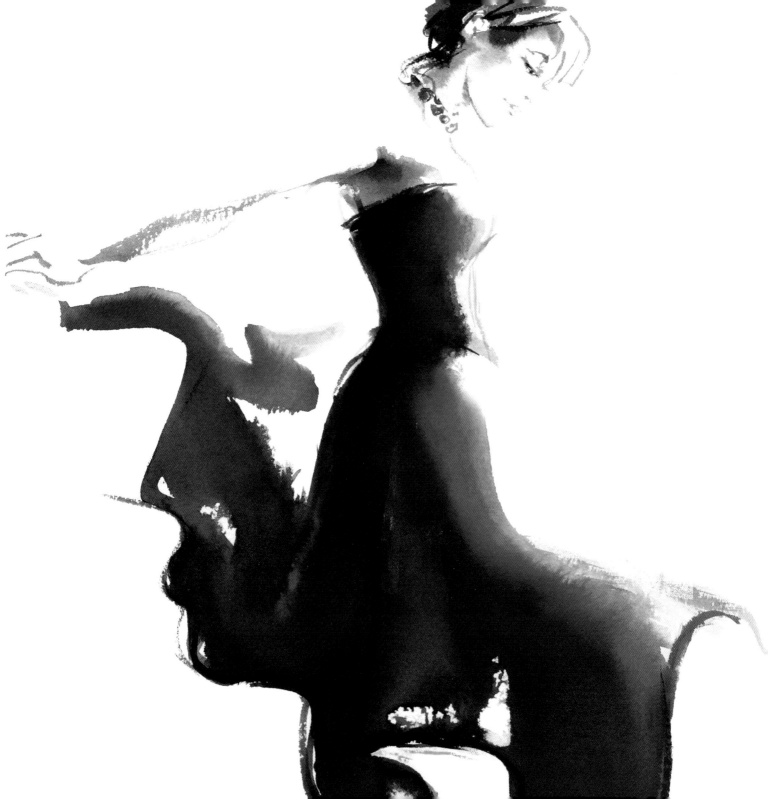

IMPACT

I have never consciously thought about my work as having impact. I don't start a painting and decide 'this one will have impact'. Painting is like speaking a language; the more fluent you become the less you have to think about the grammar, pronunciation or rules. You have to know all these things in order to forget them, and to speak, or draw, from the heart instead of the head. Then if everything gels in the right moment you will find your own style and if you are lucky — once in a while — impact!

Viewpoint

You place yourself in every image by the information you give away about your viewpoint. Use this information to select, edit or exaggerate the elements in the image that you want to focus on. Look for something unusual in the model. By moving to a new viewpoint your subject will change. By viewing your subject through 360 degrees you will gain a more complete understanding of it.

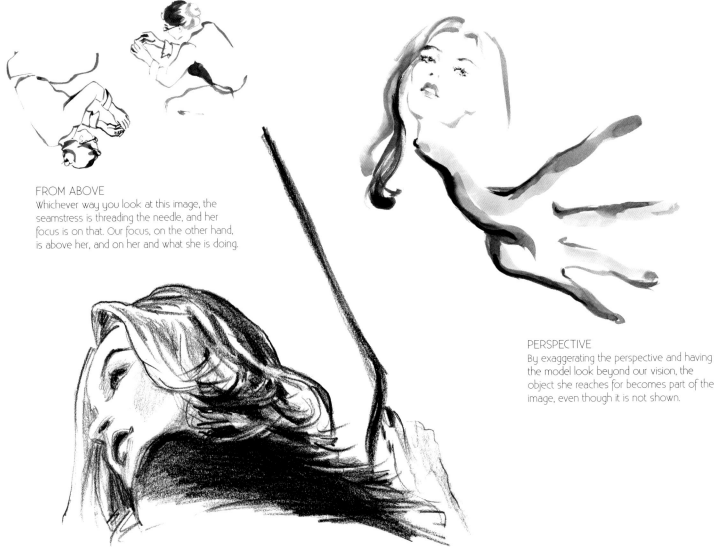

FROM ABOVE
Whichever way you look at this image, the seamstress is threading the needle, and her focus is on that. Our focus, on the other hand, is above her, and on her and what she is doing.

PERSPECTIVE
By exaggerating the perspective and having the model look beyond our vision, the object she reaches for becomes part of the image, even though it is not shown.

FROM UNDERNEATH
In this image, and the one above right, the areas closest to our viewpoint are darker and more defined. Objects that you want to draw closer to you have more contrast and detail; those areas that are drawn with less contrast and detail will, conversely, recede. By accentuating the closest details in this figure's hair, it gives the impression that we are very close to her.

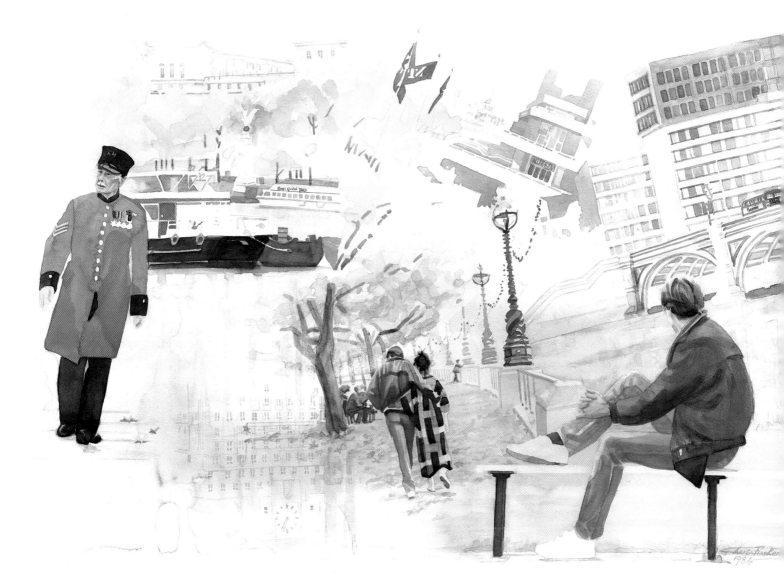

THE SUBJECT'S VIEW
As well as your own viewpoint of the subject, bear in mind the viewpoint of the subject you are drawing or painting.

The image above is a montage that has been built to represent memories of different parts of London, of its buildings, sights and the river, and of friends, created from a variety of drawings and photographs that I have collected over time. We are looking at the view as it appears before the man seated on the bench in the foreground. He appears in the centre of the image again, this time with somebody else walking away from us. His viewpoint is central to the composition, and through it we are drawn into the picture where we see the montage of scenes as if through his own eyes and memory. Try to consider the viewpoint of your subjects, as well as your own.

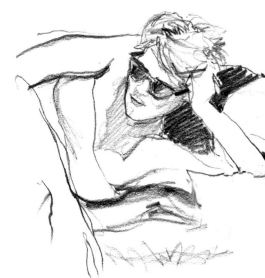

LOW VIEWPOINT

We were in Regent's Park having a picnic on a sunny day when I made this drawing of friends as I sat on the ground beside them. Had this been a formal model situation it is more unlikely that I would have been sitting down next to them. They were relaxed and at ease, and it is obvious they were not posing.

SHOWING ENERGY

Watching a friend from above about to start a drawing, I scribbled marks to show where I saw the energy to be. Had I waited for him to start drawing, that energy would have been transferred to the paper.

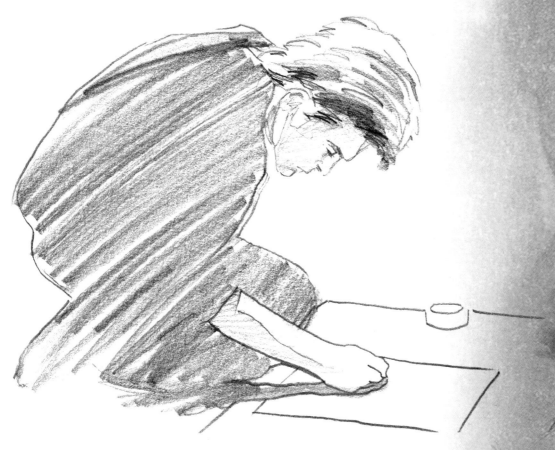

SHIFTING VIEWPOINT
I saw a photograph which reminded me of seeing a woman descending an escalator as I was on the opposite one going up. I first made a sketch to capture the fleeting memory of how she disappeared out of my view, and then made the ink version.

reviewing

The more you draw the figure, the more you will discover about it and with this knowledge will come the realization that the more you know, the more you know there still is to learn about it. Reviewing is a way of taking what you know and re-examining it, drawing the model as if for the first time, and applying all the knowledge you have acquired by having done it so many times before.

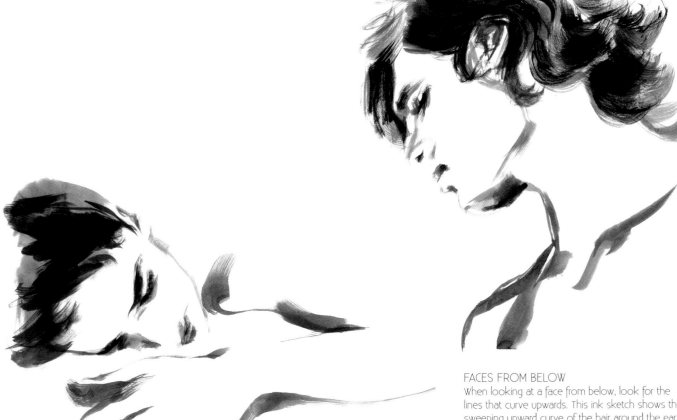

FACES FROM BELOW
When looking at a face from below, look for the lines that curve upwards. This ink sketch shows the sweeping upward curve of the hair around the ear, and the curves of the eyebrow and the jawline.

CLOSE-UPS
Moving very close to the model is also a different way of looking at it. Making the weight of line and the tonal contrasts stronger in the closest features helps draw them into the foreground.

When drawing from the figure in a formal situation, in an evening class, for instance, it is easy to find a comfortable position and then stick to it. The model is placed so that if there is a group of you drawing you can all see the figure easily. The problem with this is that you will begin to see the model from similar angles every time you draw, and you may become complacent about what you think you can see and stop looking for what is really there. Place yourself in an unfamiliar position from which to draw the figure. This will help you to review what could otherwise become a succession of familiar poses.

DIMINISHING LINES
This view shows the figure's limbs extending into the distance. The perspective is described by the diminishing lines as they converge in the background.

FORESHORTENING
This sketchbook study of a sleeping friend is an attempt to review the figure foreshortened and curled into a ball. The angles created through the line of the leg, shoulder and arm create the planes that extend the pose into the distance.

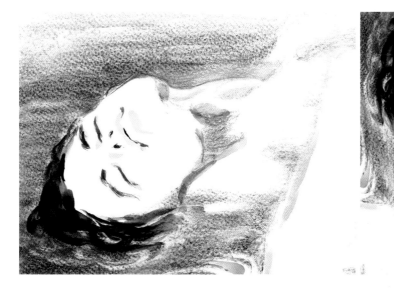

INVERTED HEADS
In the first image, from above, the lines of the man's hairline, eyebrows and mouth curve downwards. By rotating the image all the lines curve upwards and yet it doesn't seem like a man seen from below because other things happen to a head when it is turned upside-down, such as the effect of gravity on the flesh and hair, and the different muscles used to hold the head and shoulders upright.

less is more

It is often what you don't say or include that creates the impact of an image. What is suggested, and left to viewer's imagination, can sometimes be more powerful than a literal representation. The selections you make while working on a drawing or painting may constantly change until you find a balance that feels right. Being selective in this way looks deceptively simple, but is a difficult process to perfect.

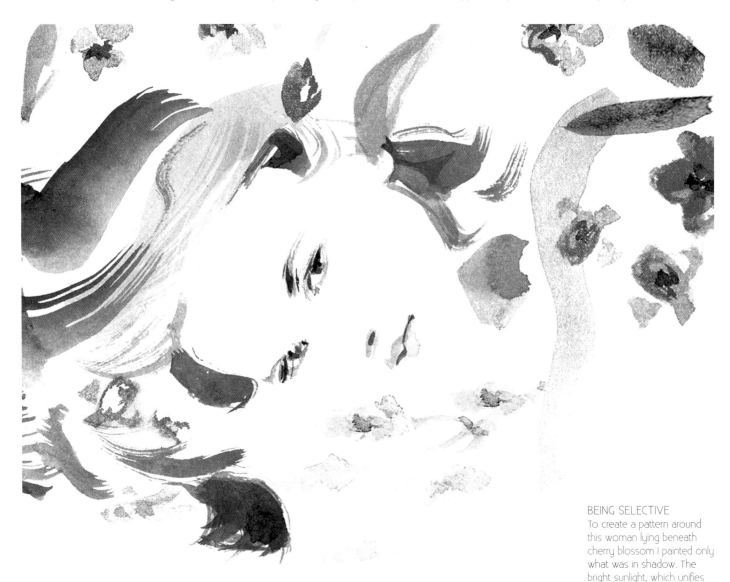

BEING SELECTIVE
To create a pattern around this woman lying beneath cherry blossom I painted only what was in shadow. The bright sunlight, which unifies the image, is represented by the white backdrop.

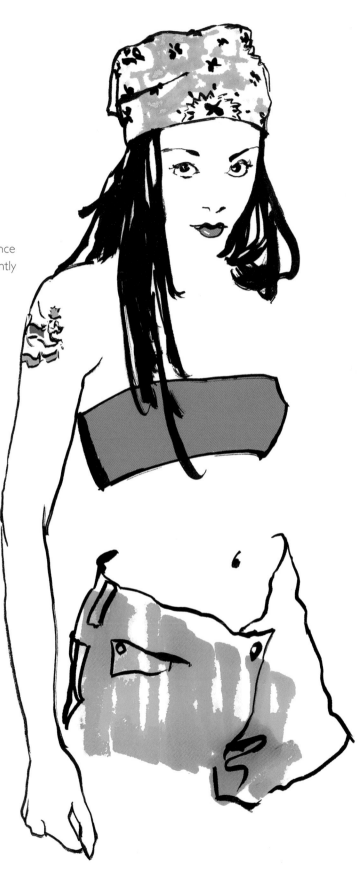

Conscious decisions

Try not to say anything more than once in an image. One strong and confidently placed mark will have more impact than any number of more tentative ones describing the same feature. As you design your image on the page remember to consider every area, making a conscious decision about its shape, size and position. The background should be considered in this way, even if you decide to leave it as untouched paper or canvas. You may have to make many drawings to achieve this balance, trying out different combinations of elements. Try scanning images and isolating areas to experiment with different colour variations.

BALANCING THE
COMPOSITION
Rosie appears out of the white space through only her eyes, make-up, hair and clothing. Her right arm anchors the image — without it, the composition would seem unbalanced.

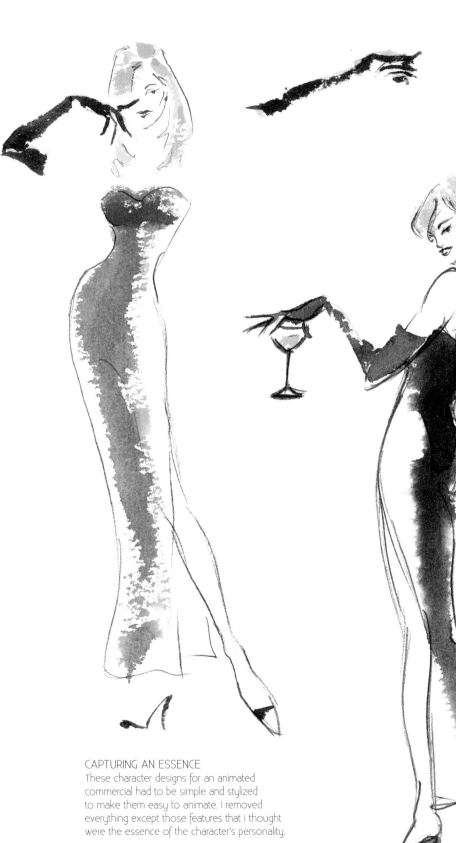

DEFINING SHAPES
For this watercolour on rough paper, the hair, gloves and dress were all created without taking the brush off the surface, so making the marks expressive and spontaneous. The pencil line is used only to define shapes that I wanted but the brush had missed.

CAPTURING AN ESSENCE
These character designs for an animated commercial had to be simple and stylized to make them easy to animate. I removed everything except those features that I thought were the essence of the character's personality.

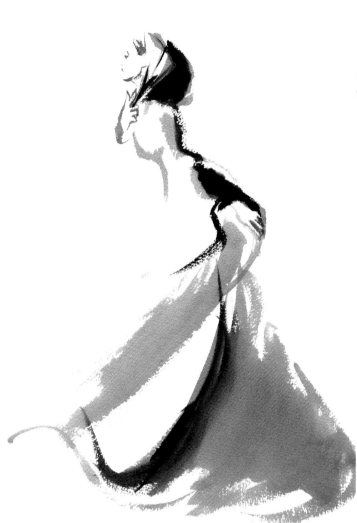

ABSTRACT SHAPES
A series of individually abstract marks in ink unite to become the hair, ear, chin, neck and hooded cloak of a woman by adding a few dots and dabs for her facial features and sweeping brushstrokes for the swirl of her cloak. By covering the face, then the hair and cloak revert to abstract shapes.

The magic
I think this aspect of painting is the most challenging but also the most rewarding – when it actually works. It is the part when you have made drawings and reference sketches and thought about the lighting and composition on the page. You have thought about form, anatomy and movement and then you put that to one side and paint what you feel. It is as if you close your eyes and paint the after-image. You won't remember all the intricate details, but you will see the impression that they made on you. It may take many attempts. Try to concentrate gurative image but think of it in an abstract way; that is, when you will see the texture in watercolour paper emerging through a single gestural brushstroke to become the highlights and folds in a pair of satin gloves or the wispy flourish of somebody's eyelashes. When that happens it always feels, to me, like magic.

lighting

Lighting is one of the most useful tools you have when drawing. The shadows that are cast will give depth and an understanding of the figure's contours and the directions of its planes and curves. Light and shade on a figure work like a grid of information that you can use to understand its shape and movement, as well as having qualities that can be used to create drama and atmosphere in your image.

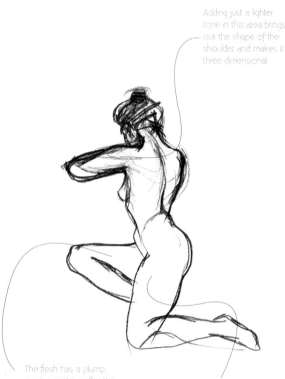

Adding just a lighter tone in this area brings out the shape of the shoulder and makes it three dimensional

The flesh has a plump, curving contour after the charcoal shading is applied

With graduated shading and blended highlights you can create the texture of smooth, silky skin

CURVES AND CONTOURS
Light and shade can be used to define curves and contours, adding depth and dimension to the figure. Try drawing the same model in the same pose at different times of the day, or lit differently with artificial light, to see how this affects the image.

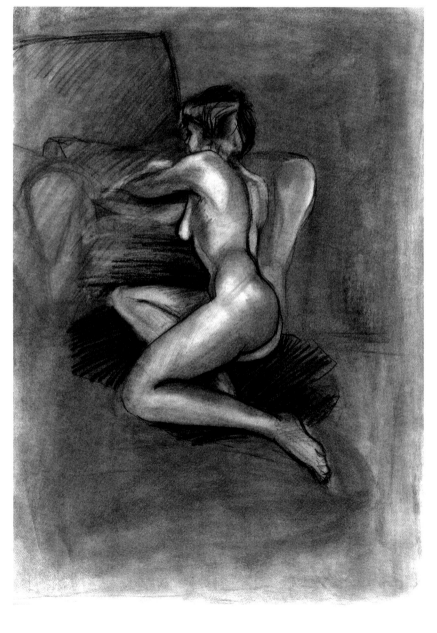

Light sources

Rather than just drawing the light as you see it, you can use your imagination and create your own light source and its effects by following the shapes of the contour on the figure. For example, use studies made from life; experiment using sheets of layout paper on top of them and, following the contours, create your own alternative lighting scenarios. Make simple watercolour or ink sketches to experiment with lighting and how light can bleach out areas of detail.

DRAMA OF LIGHT
To record this figure sitting in darkness, I picked out the shapes the light made as it fell on the figure to create atmosphere and a sense of drama.

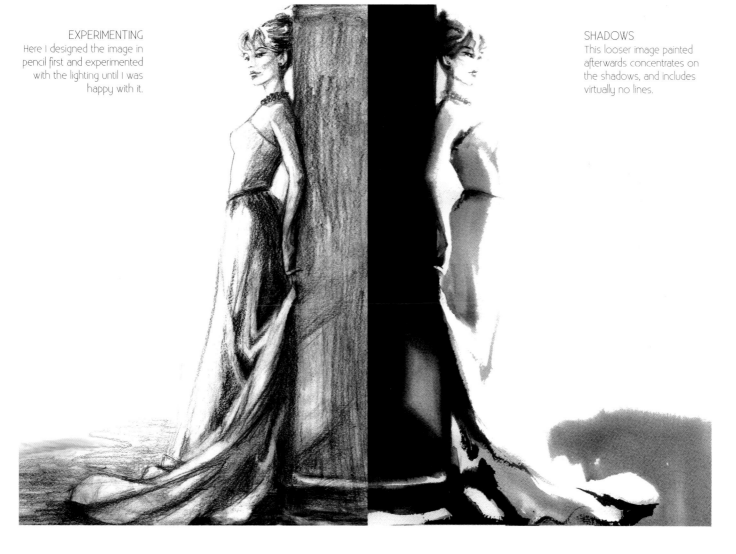

EXPERIMENTING
Here I designed the image in pencil first and experimented with the lighting until I was happy with it.

SHADOWS
This looser image painted afterwards concentrates on the shadows, and includes virtually no lines.

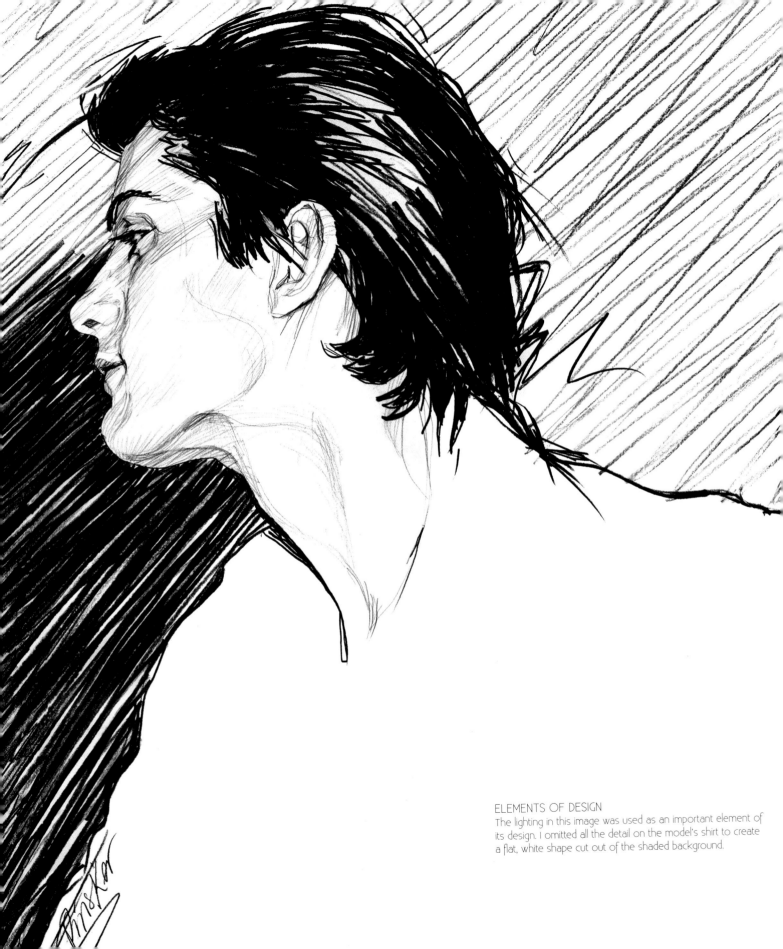

ELEMENTS OF DESIGN
The lighting in this image was used as an important element of its design. I omitted all the detail on the model's shirt to create a flat, white shape cut out of the shaded background.

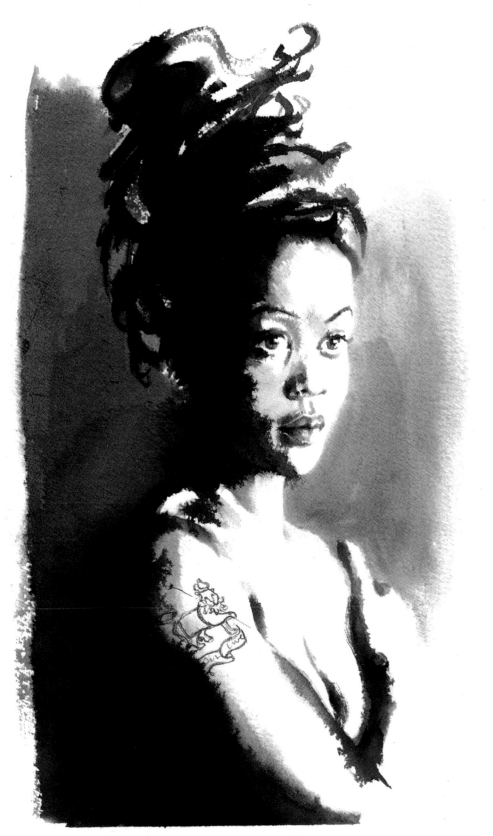

Yin and yang

If you use watercolour on white paper you will always be painting in the shadows, either by defining the light around them or by painting into them. If you paint on oil on canvas, on the other hand, you will paint the darker areas first and then apply the light areas on top of them. Whichever way you apply the shadows and light, you must always be aware of the shape you are creating in the areas you are not painting. So when you paint a dark, shadowed area be aware of the shape of the light next to it. Allow that to define the shape of the darker area. Think of it as yin and yang.

SOFT LIGHTING
This watercolour image was painted in monotone to allow the soft lighting to colour the image with just light, mid-tone and shadow.

mood

I had been working on an image for the video sleeve of a Manga film, *The Professional*. The brief was 'looking down the barrel of a gun held by a gangster caught on a rooftop, in the searchlight of a helicopter'. I was not making any progress so I called Bruno who had employed me for the job. He came over to see what the problem was. 'Well where's all your reference material,' he asked, 'and how on earth can you work on this listening to a gardening programme? Put on some hiphop and make it loud!'

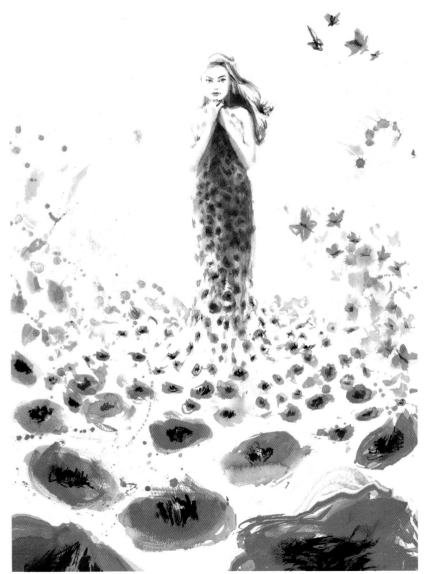

Immerse yourself

This eluded me for years, and seems so obvious now. While working to a brief or a story line, it is a great help to have around you reference materials that relate to the original inspiration and help you to visualise it. Once you can picture what an image will look like it is so much easier to start making it. From there you can still explore alternatives but it is easier to experiment and still stick to a brief when you have the things to remind you of it around you.

CAPTURING THE MOOD
Looking at a field of poppies conjured up this image of a billowing silk printed dress out of which is emerging a figure as if in a dream — the flowers on the dress turning into butterflies and flying off into the distance. In my mood board, opposite, I experimented with abstract watercolour splashes, which I used here to add a surreal look to the poppies and butterflies. The silk chiffon ribbons and shiny stones, collected as part of the mood board, have textures and elements that help recreate the mood that conjured up this imagery.

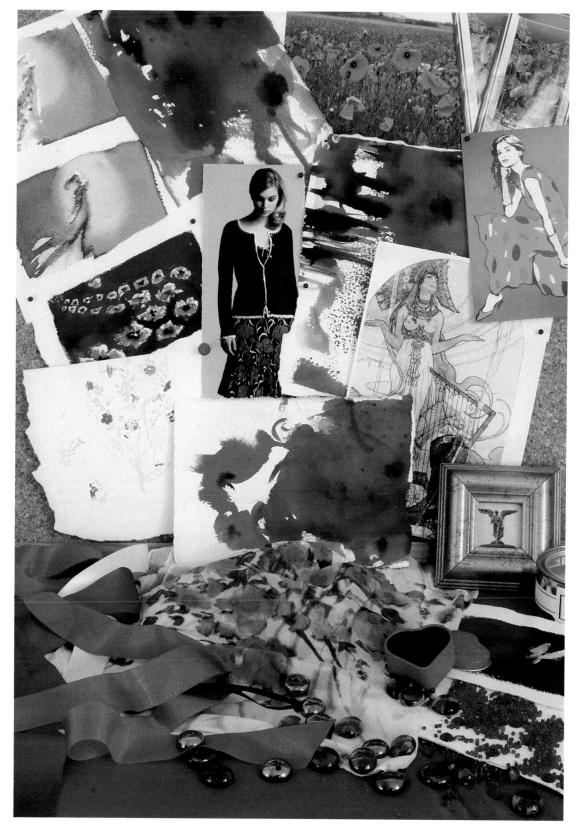

PIN UPS
A mood board can be made up of anything — rough sketches, photographs, colour swatches, textures or fabric samples (and don't forget how evocative music can be!). In fact gather *anything* that will help conjure up the theme. If you put together as many elements as you can to create the 'mood' of the image then the more likely it is to appear to you.

metamorphosis

Drawing the figure holds an almost infinite variety of possibilities for me. Like being madly in love with someone, one never tires of gazing at them. As the artist Andrew Wyeth, who spent a year painting the same model, Helga, wrote: 'My struggle is to preserve that abstract flash, like something you caught out of the corner of your eye, but in the picture you can look at it directly. It's a very elusive thing.'

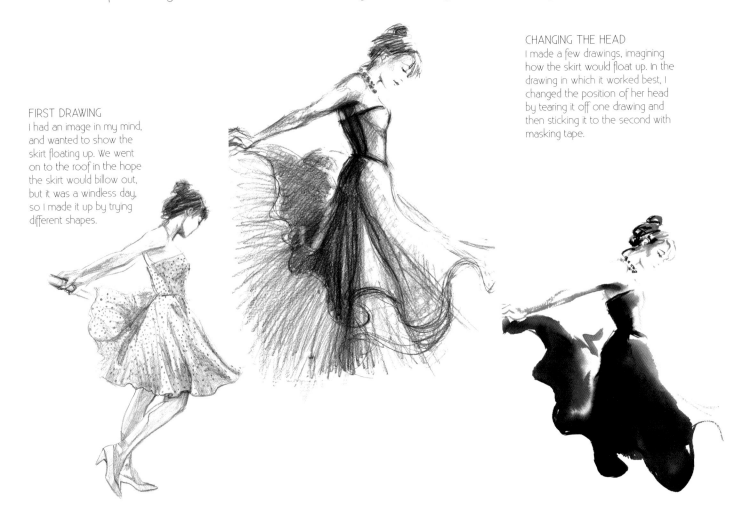

CHANGING THE HEAD
I made a few drawings, imagining how the skirt would float up. In the drawing in which it worked best, I changed the position of her head by tearing it off one drawing and then sticking it to the second with masking tape.

FIRST DRAWING
I had an image in my mind, and wanted to show the skirt floating up. We went on to the roof in the hope the skirt would billow out, but it was a windless day, so I made it up by trying different shapes.

Start by making some sketches that contain as much information about the model, pose, lighting and movement as you like. Then you can change such elements as the clothing and combine elements from drawings you have in your sketchbooks until you have the basic composition and design you are happy with. Don't be tempted to go over the same drawing or use an eraser – this will make the image overworked and it will lose its spontaneity. Use layout paper or a lightbox so you can lay sketches on top of each other to try out different combinations of elements.

FIRST PAINTING
This was the first painting I made after the working drawing. I wasn't happy with the head, arm or dress, but I kept repainting it.

REPEATING AND REJECTING

These are some of the rejected heads I made for the figure.
The style of the painting was dependent on a minimum of
brushstrokes placed in the right place with the right emphasis,
so if I made a mark that wasn't right I had to start all over again.

I tried to find a happy
medium with the black
in her hair but was still
not convinced and
abandoned this one
before trying any tone
in her face

Here the overall tone
of hair and skin were
not strong enough for
the rest of the image.
It needed to have
more black in the hair
and something more
– maybe red in face

I was much happier
with this one but still
wanted to try more
tone in her face

I tried to paint more
black into the hair but
overdid it – I made the
jawline too deep this
time too

In this image I defined the whole of the shoulder and arm but felt they pulled the figure backwards

PERILS OF OVERWORKING
Although I liked the sweep of the material coming towards us, I had overworked the rest of the dress. In doing that I lost the lighting on both the front and back of the figure. Once something is overworked you cannot regain the spontaneity – you have to start again.

SELECTING ELEMENTS
The painting on the left was the image that I preferred of the many I made, but I wanted to remove the line defining the model's shoulder and arm, and to use instead the arm from the painting above.

Although the shadow underneath the upper arm was working here, it was too dominating, and unbalanced the composition

THE RIGHT DRESS
The bleed of the colour in this dress and the texture of the watercolour paper coming through the highlights gave this one the movement and spontaneity I was looking for.

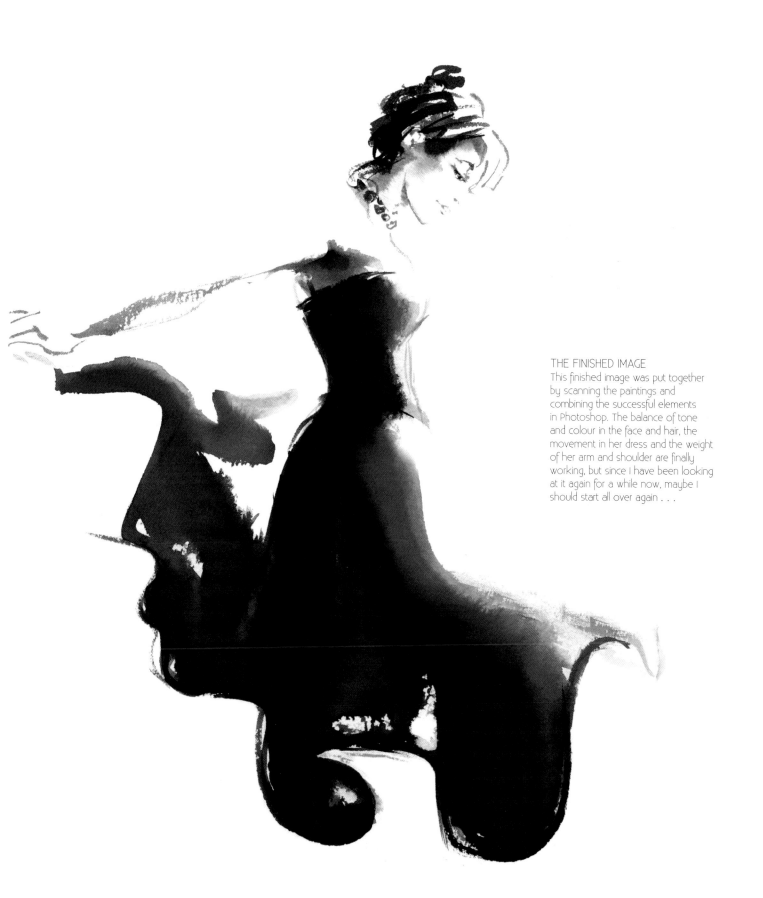

THE FINISHED IMAGE
This finished image was put together by scanning the paintings and combining the successful elements in Photoshop. The balance of tone and colour in the face and hair, the movement in her dress and the weight of her arm and shoulder are finally working, but since I have been looking at it again for a while now, maybe I should start all over again . . .

PEPPERCORN
This poster for singer-songwriter Rosie Jones includes spiritual motifs related to her, such as the crown and moon, that are inseparable from her music. I made several pencil sketches, and then pen and ink drawings in each colour, bringing them together in Photoshop.

PORTFOLIO

These images were mostly commercial assignments and commissioned work, but whatever the purpose, I try to see the figure in a unique situation and understand the story behind it. I start by making sketches, sometimes using a model or reference photos, tearing bits off one drawing and sticking them to another. Whether I work with watercolour, charcoal or Photoshop, the original drawing remains a key element.

CIRCUS BOYS

少年読本
二十世紀

CIRCUS BOYS
This image for the video
sleeve of the film "Circus
Boys" had to have drama
and a sense of poignant
foreboding. I chose to use
charcoal and to pick out only
the detail of the figures, the
light catching the curtains and
the circus tent in the distance.
The colour of the tattoo on
the boy's back was painted
in gouache.

CHARLES
CHAPLIN
AWARD
EDINBURGH
1990

ICA
PROJECTS

15

artist partners
2007

ARTIST PARTNERS
This image was created for the cover of an artists' agency brochure to illustrate that 'every picture tells a story' and 'you can't tell a book by its cover'. The story is about a crime of passion in which the man stabs his unfaithful wife during the tango. The image conveys the moment he lets her fall back into his arms, the knife in her back . . . But to the rest of the world, they seem only to be dancing.

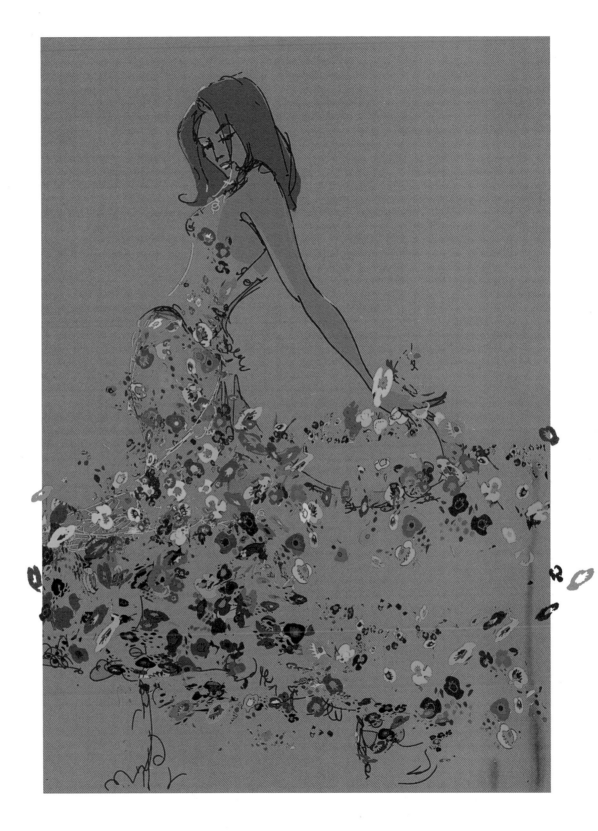

BARBARA
As this illustration was a commission for a fashion publication, the dress is the central point of interest. The image was created from a combination of scanned images — the drawn head, flesh tones and the billowing dress — laid on top of each other in Photoshop to create an imagined, rather than literal, representation.

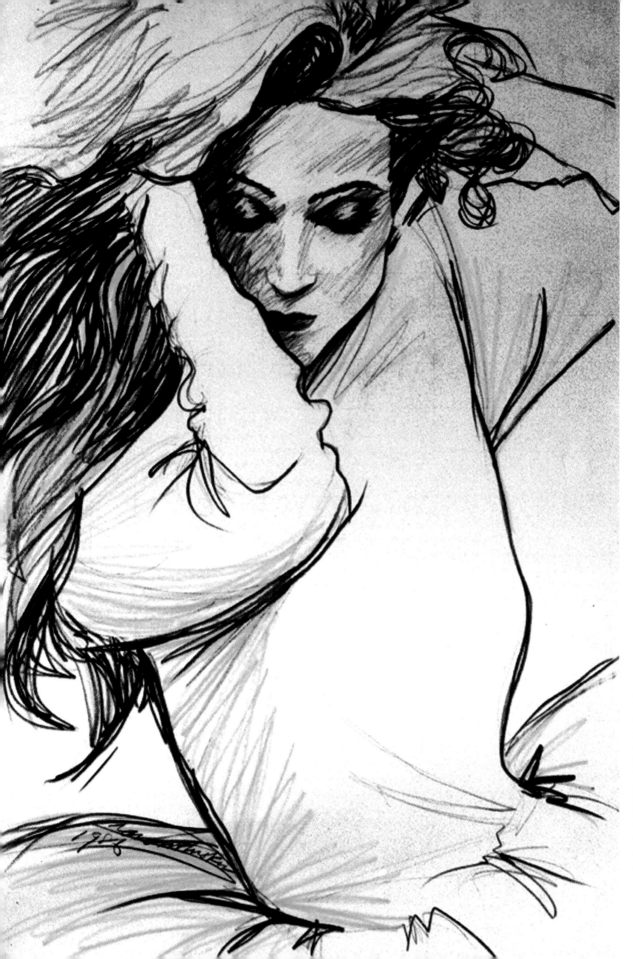

JELENA
This drawing was
commissioned to go in an
apartment store window,
and had to be about eight
feet high. I squared up from
smaller sketches onto a
roll of cartridge paper. Using
jumbo aquarelle crayons,
I was able to create
vigourous directional marks
which helped give the
drawing movement and the
attitude I wanted.

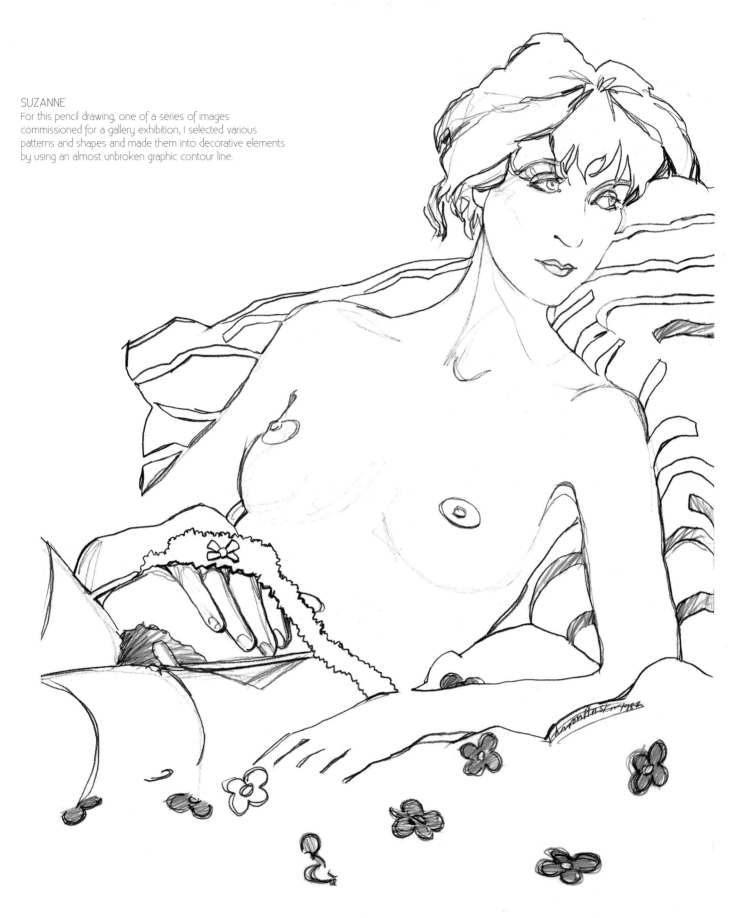

SUZANNE
For this pencil drawing, one of a series of images
commissioned for a gallery exhibition, I selected various
patterns and shapes and made them into decorative elements
by using an almost unbroken graphic contour line.

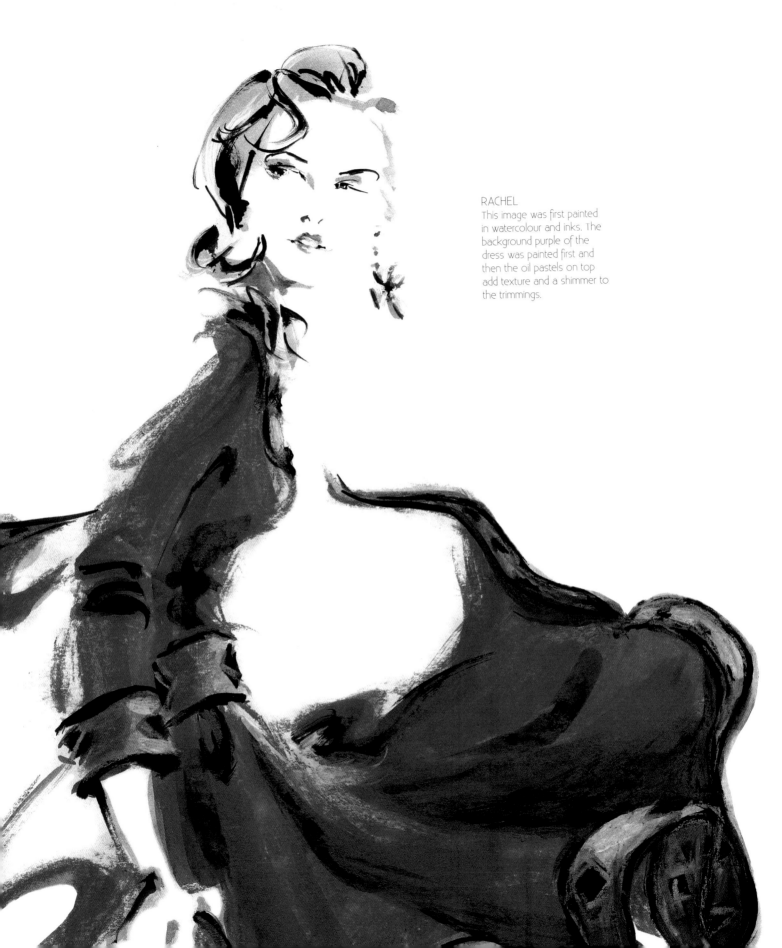

RACHEL
This image was first painted
in watercolour and inks. The
background purple of the
dress was painted first and
then the oil pastels on top
add texture and a shimmer to
the trimmings.

AMY
This is my rather idealized and romantic version of performing artist Amy Winehouse. It is the original style frame used to show the character design which is then to be animated and combined with live action footage of her.

CAMILLA
Computers undoubtedly make life easier
and save time in an infinite number of ways.
This image was simplified by scanning it in to
photoshop and then separating the colours
out so that i could select and fill them using a
variety of combinations of various tones and
colours. The only trouble with this excellent
freedom to experiment is that, even in the
simplest of images, the time you save in the
labour of painting you may well loose in
endless indecision.

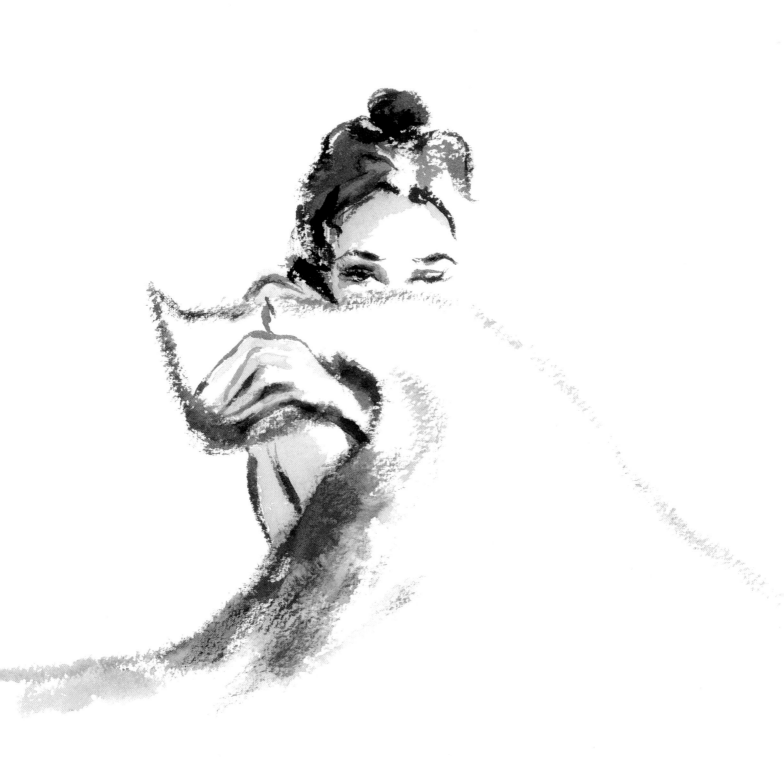

KAREN
This image was commissioned to promote a range of
luxury bath products. First I made many sketches on
layout paper, overlaying them until I felt I could achieve
a spontaneous and gestural image with watercolour.
The texture of the towel is made by using a dry-brush
technique and applying paint in overlapping layers.

ABIGAIL
This was originally one of a few working
sketches made while accumalating reference
material for a different illustration. But as often
happens the spontaneity and freedom of
working drawings and thumbnails gives them a
quality that can be lost in the refining of the final
image.

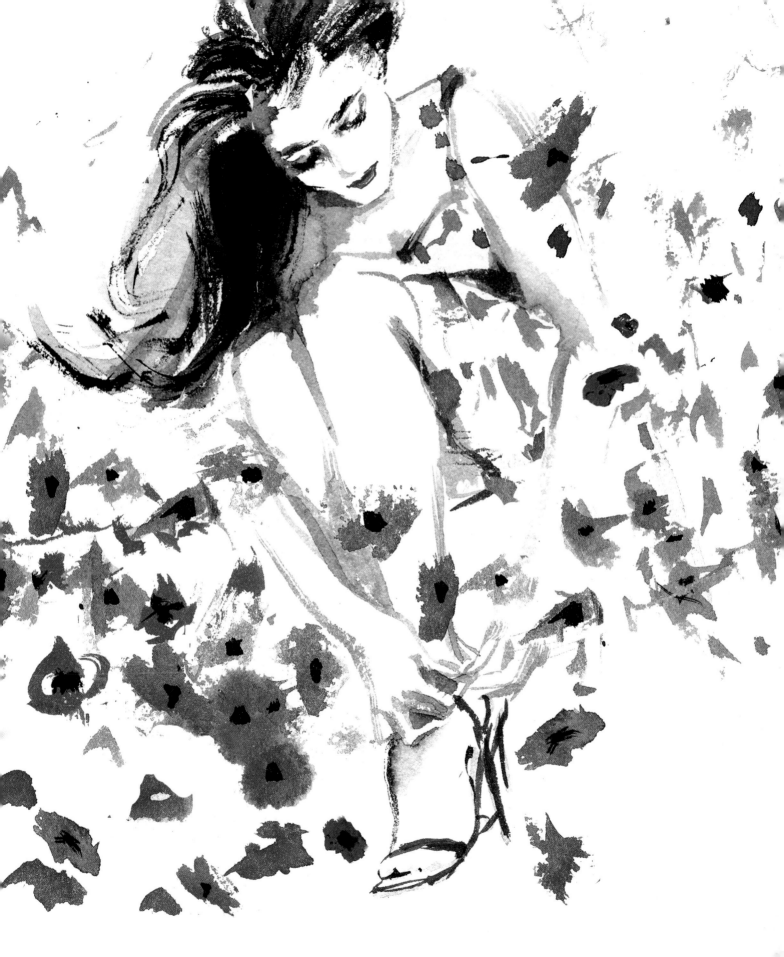

MALL OF AMERICA

This is a detail from an image commissioned as one of a series of posters to promote a shopping mall in the US (left). The figures were painted on watercolour paper and then the colour and decorative elements were multiplied on to the image in Photoshop. The flat colour of the hair, flesh tones and jacket were painted on the computer using the brush tool.

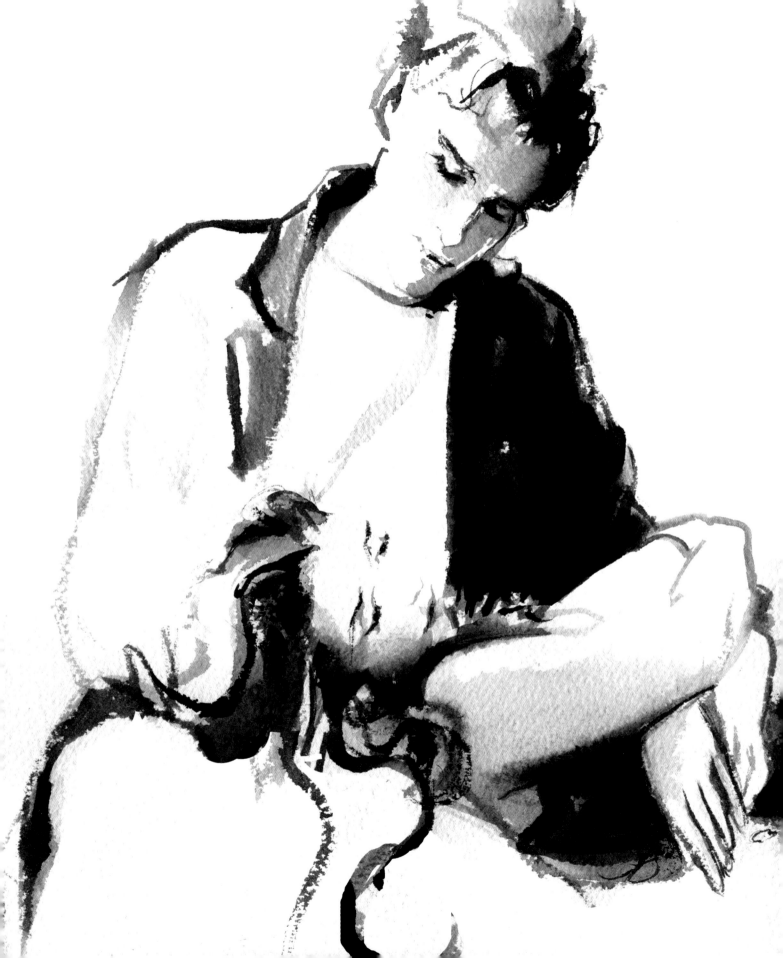

COLOSSEO STATION, ROME

For this brush and ink sketch on rough watercolour paper I used a loose wash for the girl's skirt and the couple's skin. This wash created the balance between the bright, open areas of the boy's T-shirt and the girl's face and the black shape of his jacket, which defines her arms.

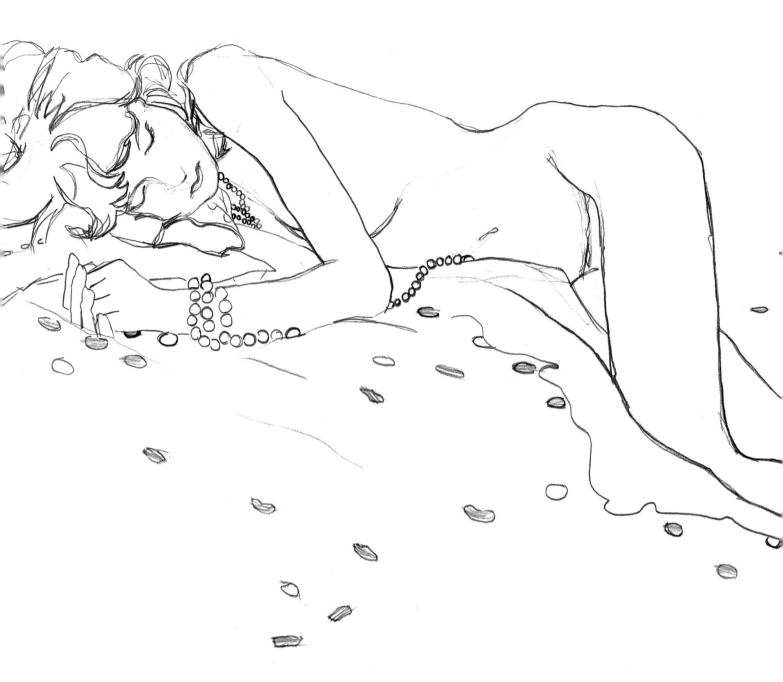

SUZANNE
This drawing of my patient and long-suffering sister was made at the end of an afternoon of modelling for me. She was fed up and tired because I kept asking her for 'one last pose'. When she fell asleep this turned out to be the most successful image of all, possibly because her mood has permeated the image. This is something I would love to be able to make happen at will.

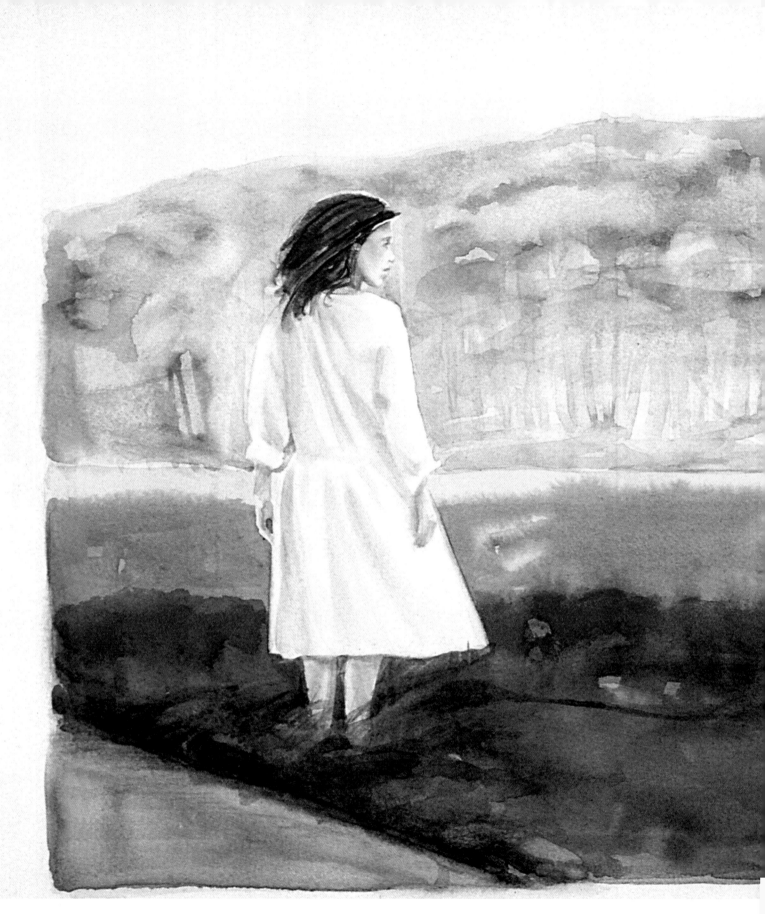

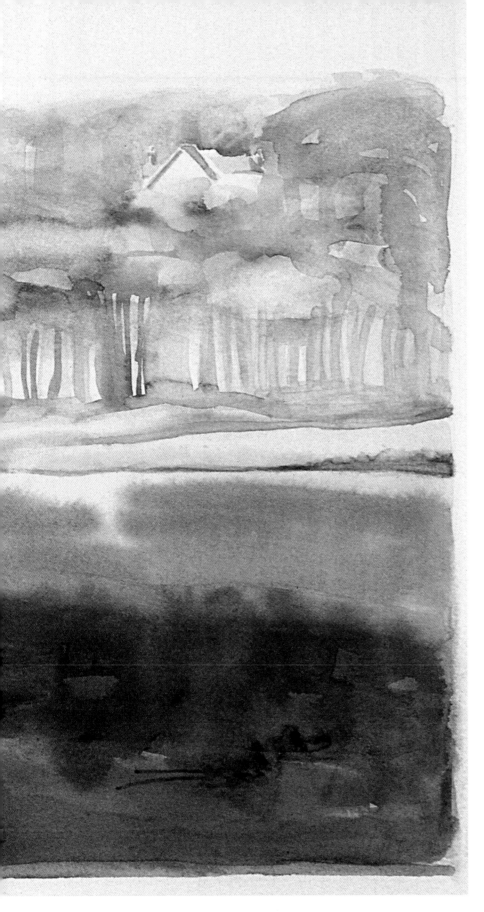

HOME IS WHERE THE HEART IS

This watercolour impression of the Robbins-Zust family home is the view of it from East Road through the trees. I made the painting when I knew I was having to return to London after many happy months spent in the Berkshires, New England. This image is about me reflecting on how much I would miss that wild and magical place where it seemed time stood still, although sadly it didn't.

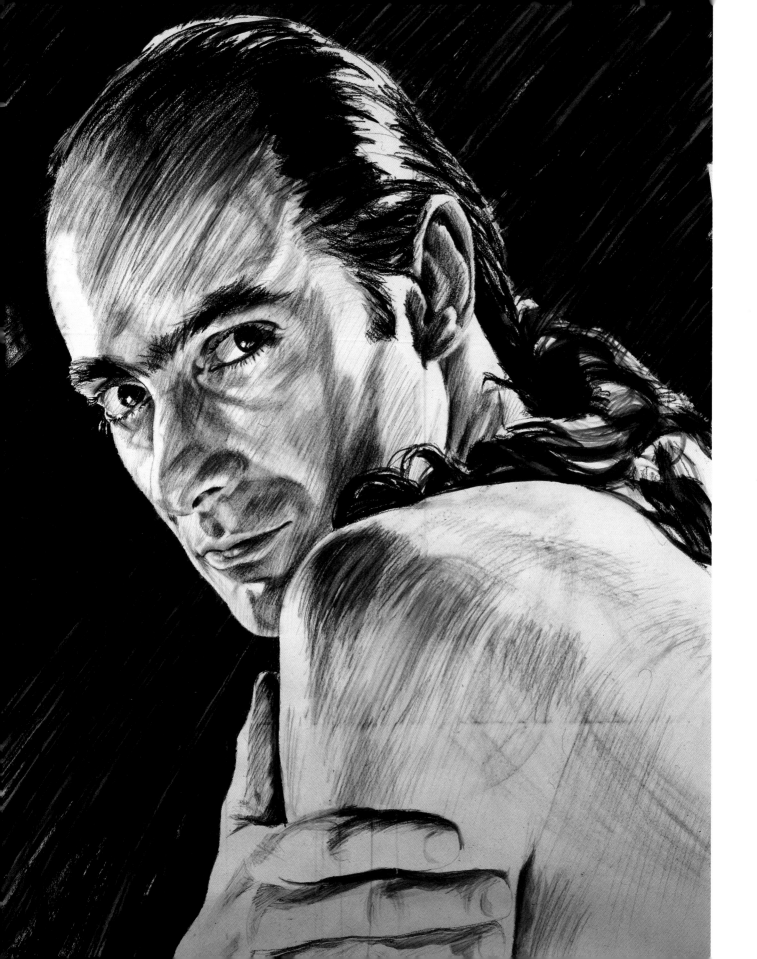

BRUNO
This is a large drawing
measuring more than six feet
high made with aquarelle on
paper, which I scaled up from
small preparatory drawings.
Bruno is a friend who I wanted
to show as a generous and
sensitive man, as opposed
to having an unapproachable
and intimidating nature that his
high-powered job as a creative
director sometimes suggested.

JADE
This is an image of Jade
Caffor. She has been the
inspiration for so many
images so I think of her as
my Muse. It's one in a series
of images 7 x 5in. Instead of
painting onto a large piece of
watercolour paper, as I have
done previously I printed
the original watercolour on
to canvas so that the grain
of the watercolour paper
becomes vastly enlarged.
The grainy texture combined
with the loose weave of the
canvas was an integral part
of the abstract paint effect I
wanted to achieve.

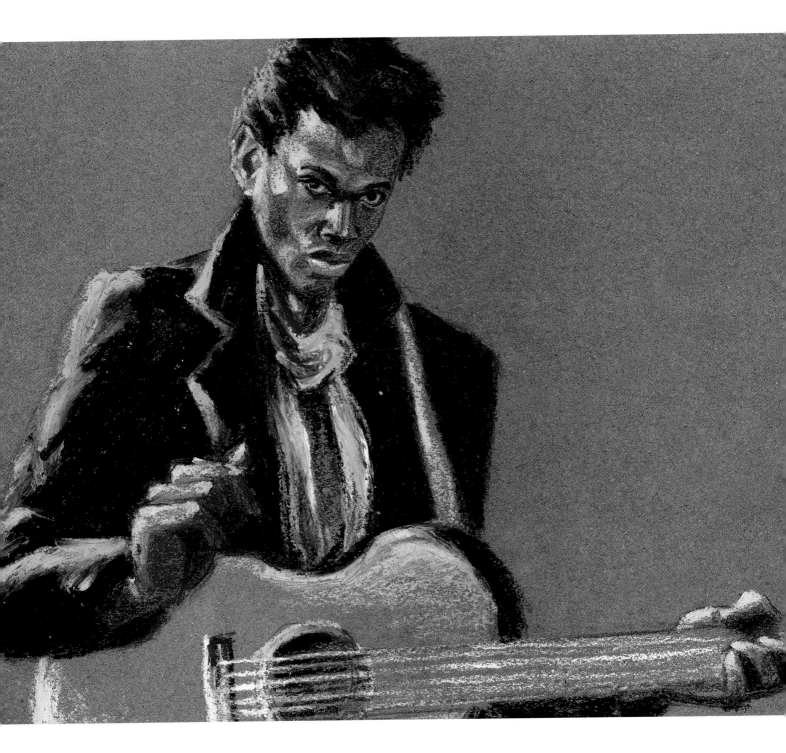

JOEY
This image of Joey was done with oil pastels on coloured Ingres paper. I built up impasto layers of the pastel in some darker areas to create the shine on the velvet jacket and on his hair. I left the face of the guitar open to allow the grain of the paper to come through the thinner layer of pastel to create a wood-like texture.

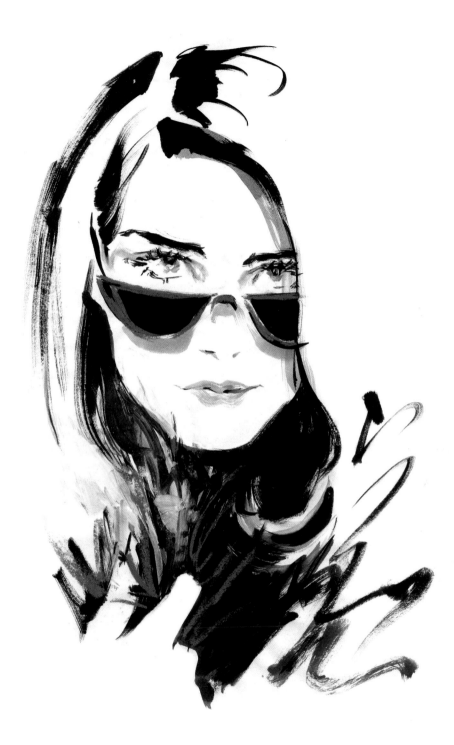

ANNUSKA
The rims on the sunglasses of this brush and ink
painting on cartridge paper are picked out in gouache.
The feather boa is made from a combination of ink and
oil pastel strokes of varying pressure.

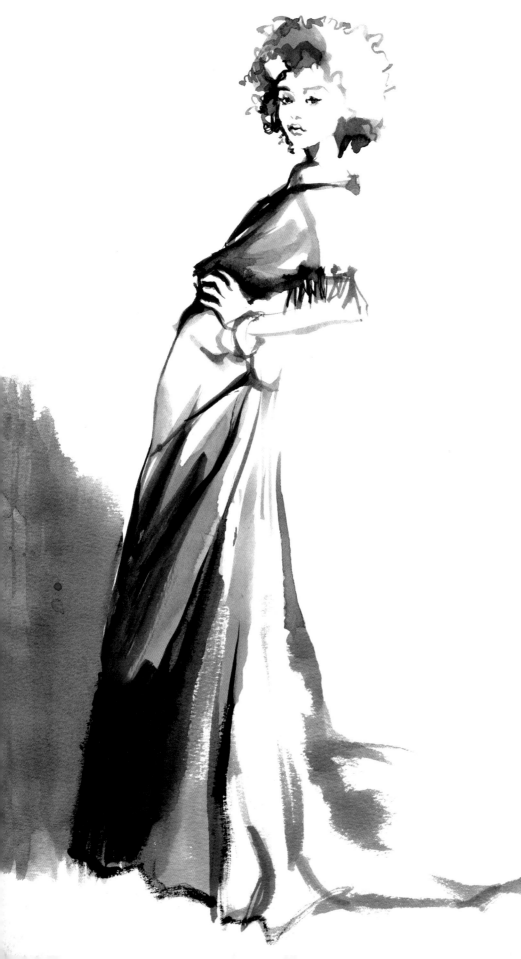

ONE
This was one sketch in many attempts
to convey the natural ease in the
pose of the model while also trying
to achieve the elegance and drama of
the clothes she is wearing. I used brush
and ink on rough watercolour paper.

JENNY FOX-PROVERBS
This portrait had to be done using
only photographic reference of
Jenny who I have never met... but
during the course of her project-
editing this book we talked many
times over the phone so I hope,
if not a faithful physical likeness,
something of her personality has
managed to get through!

ACKNOWLEDGMENTS

THANK YOU FOR THE USE OF IMAGES:

Astral

BBC

Mike Bennion

Crabtree & Evelyn, Robin Anderson

Joey Ducane

Mark Farrington

Godiva

Granada, Ed Bignal

Hibert Ralph Animation, Jerry Hibert

Hyperion Books for 'Jimi & Me' from *Jump at the Sun*/Hyperion Books for Children/ Disney Book Group (3rd imprint)

IPC Magazines

Ed Ironside

Mick Jagger

Rosie Jones

Kerker, Chris Preston.

Mall of America

Manga

One, Ledbury Road W11

Penguin Books and Michael Joseph

Peppercorn

Pepsi/Aquafina, Debbie Fries

Julie Pye

Iggy Pop illustration based on copyrighted photos by Mick Rock, with his kind permission

Saga Films

Saatchi & Saatchi

Dave Waters

And to anyone who has been left out in error, sincere apologies and thank you.

THANK YOU ALSO TO:

Freya Dangerfield, Sarah Underhill and Jennifer Fox-Proverbs at David & Charles

James Hobbs

Bruno Tilley

To every model, especially Jade Caffor and Suzanne Pinsker

Christine Isteed at Artist Partners

Barbara and Steven Brunswick

Ann and John Pick

And most especially of all my guiding light Martyn Pick

INDEX

Book cover designed and illustrated for Michael Joseph an imprint of Penguin Books Ltd. Designer Alison Groom.